CHINESE PAINTING

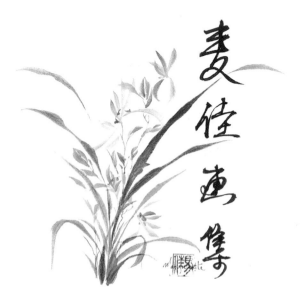

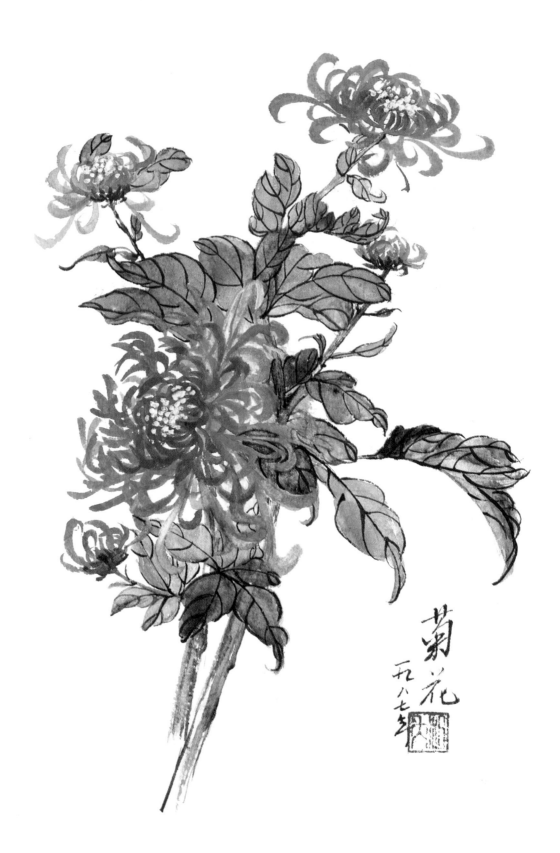

菊花
一九八七

CHINESE PAINTING

Ideas and Inspiration

MARGUERITE
FRANKLIN-CARRIER

STUDIO
VISTA

Studio Vista
an imprint of
Cassell
Wellington House, 125 Strand
London WC2R 0BB

Designed by Judy Linard

First published 1995

British Library Cataloguing in Publication Data
A catalogue record for this book is available from the British Library

ISBN 0 289 80131 1

Distributed in the United States
by Sterling Publishing Co., Inc.
387 Park Avenue South, New York, New York 10016–8810

Distributed in Australia
by Capricorn Link (Australia) Pty Ltd
2/13 Carrington Road, Castle Hill, NSW 2154

Printed and bound in Spain
Typeset by Litho Link Ltd, Welshpool, Powys, Wales

Acknowledgements

致 謝

I wish to acknowledge the generous encouragement of all my students and friends; also the support in my endeavours shown by my husband Michael, Antony Cartwright, James Martin, the late Margaret Cahill and Anthony Hill.

The Three Friends of Winter

The Three Friends of Winter, as they are called by the Chinese, are the prunus blossom, the bamboo and the pine. All three stoically withstand the ravages of winter, giving brightness and colour in those dark days. The prunus puts out its delicate, joyful blossoms even when there is snow on the ground. The flexibility, durability and stability of the bamboo enable its lean, sturdy stems to hold out against the winter frosts and gales. And the pine tree, through its immovable strength and richness of colour, symbolizes unwavering friendship even in adversity.

OPPOSITE PAGE The Three Friends of Winter

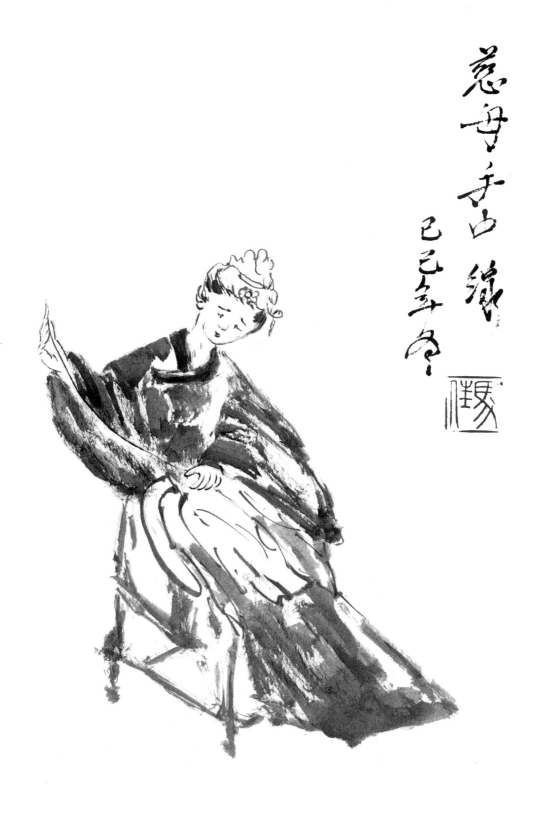

慈母手中線

己巳年冬

Thread in the hand of a loving mother

Introduction

The ancient Chinese considered painting the purest form of art, worthy to stand alongside poetry and philosophy. Indeed, many painters were also poets, and executed their work in beautiful calligraphy. The techniques and materials of these two art forms, elegant in their simplicity, are similar; to the Chinese, therefore, painting and calligraphy became known as 'the twin brush work'. Both are described in this book.

The subjects of traditional Chinese painting are generally drawn from the natural world – sometimes a complete landscape, but more often an exquisite detail of a flower, a bird or an insect. Human beings, if present, and man-made structures such as houses and bridges, are usually subordinate to nature.

The relationship between different elements in a composition is always important, and is closely connected to Chinese philosophy. Yin and Yang – the two complementary opposites that figure in all aspects of Chinese culture from medicine via martial arts to cookery – are the foundation. These ideas are expressed in painting in a thousand different ways: for instance by the contrast between light and shade, colour and monochrome, delicate blossom and rugged branches, painted images and white space. Similar contrasts can also be seen in Western art, but Chinese art is unique in

the way that these opposites combine to create a perfect harmony.

The aim of this book is to share with Western readers some of the techniques and underlying ideas of traditional Chinese painting so that you may be better able to enjoy and appreciate this beautiful art form. Then, as you practise the age-old art of Chinese painting for yourself, you can go on to develop your own personal style based on the knowledge imparted in this book.

Each iris leaf must be completed in a single stroke, even though they often fall in complex twisting shapes

Paper

紙

For about a thousand years the Chinese used silk for writing and painting, but the invention of paper in about the second century AD brought about great changes. Paper was both cheaper than silk and also highly suitable for brushwork, in particular the crisp lines of calligraphy, because of its absorbency. As a result silk declined in popularity and today is used only occasionally.

China is a huge country with a wide range of climates and a corresponding variety of indigenous plants. For centuries paper was produced in workshops near the source of the raw materials, which included flax, bamboo, mulberry bark, wheat straw and wisteria shoots, depending on the locality.

Nowadays it is rice paper, made from various materials including cotton and fibres from the rice plant, that is used for painting and calligraphy. The ideal paper is one which takes ink and colour well; it should be fine and soft, with a silky sheen. There will be a smooth and a rough side – it is the smooth one that artists use. Although all kinds of rice paper have the desired quality of absorbency, different types suit different techniques. If you have access to a good supplier of Chinese art materials, it is worth experimenting.

Modern Western watercolour paper can be used as an alternative if traditional Chinese paper is unobtainable, but it

needs special treatment before starting to paint on it. First soak it in water for between one and six hours, depending on the strength and thickness of the paper, then lift it out carefully and secure it flat on a board. As it dries, it will stretch.

Whatever kind of paper you use, it should be pinned to a drawing board or other flat surface while you are working. Between the board and paper you need a layer of blotting paper, soft cloth or newspaper to absorb any excess fluid.

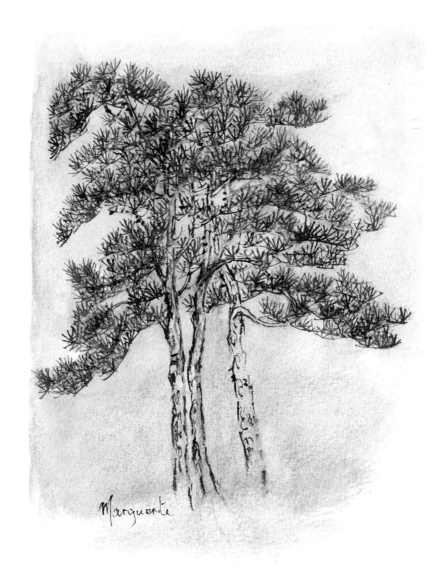

Even in winter the pine keeps its green needles as
a reminder of the spring to come

Colour

顏　色

Chinese painting uses two media – watercolour and ink. Although these media exist also in the West, the Chinese ones are slightly different.

The basic colours are all natural, derived either from plants (examples are indigo, gamboge yellow and cinnabar red) or minerals (such as red ochre, vermilion, malachite green and flake white). They are available in tubes or pans from good artist's suppliers.

If you cannot obtain proper Chinese colours you can substitute Western watercolours, but you will usually need to mix them by eye to obtain the equivalent colours.

How to Use Chinese Colours

COLOUR MIXING

Two or three Chinese colours can be mixed together, as with any paints, to produce another tint. For example:

- gamboge + indigo = green
- crimson lake + indigo = purple
- green + red ochre = dark green

Stir the colour in a saucer with a little water.

You can also blend colours in succession on your brush. First soak the brush with one colour, then with another. For

instance, to paint a flower petal first soak the brush with white, then dip the tip into crimson lake.

COLOUR HARMONY

When you are composing a picture it is best if you have no more than two principal colours, while all the other colours are subordinate. The principal colours can be either striking or subdued ones.

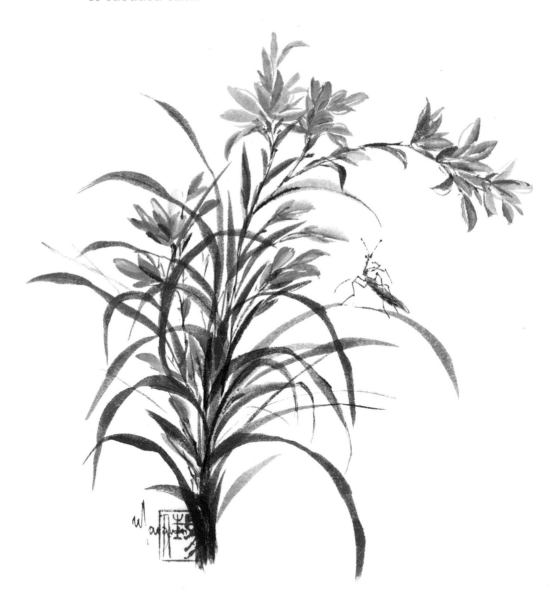

A small brown insect contrasts with the vibrant
colour of these flowers

Ink

墨　汁　與　墨　硯

The Ink Stick

A highly effective yet simple medium for painting and writing, ink is one of the most important inventions of the Chinese. Without it, traditional Chinese culture can hardly be imagined.

For centuries Chinese ink has been made in the form of a stick or similar shape, often embellished with characters or other images to create a work of art in itself. The basic materials used in the production of ink are:

- soot 　煤灰　(burnt pork fat)

- glue 　膠水　(deer glue as binding matter)

- aromatic mixtures 　有香氣的混合物

The Ink Stone

To produce liquid ink, the ink stick is rubbed in water in a special ink stone or trough. The stone is smooth and usually round, with a groove in one corner to drain off the ink when the grinding process has been completed.

15

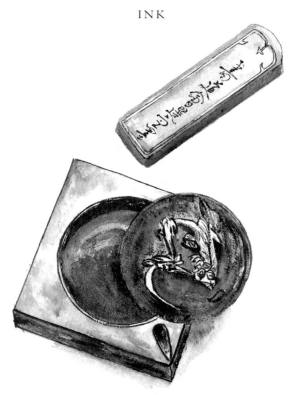

Materials for making Chinese ink: TOP an ink
stick decorated with Chinese characters, and
BELOW an ink stone with its lid removed

Grinding the Ink

The ink stick is ground in only a small quantity of water, with
slow, circular, clockwise movements. The best kind of ink
stick produces a permanent ink-black colour that will not fade
over time.

Diluted ink is traditionally graded into five shades called
charred, deep, dark, light and pale. Charred ink is very, very
black, and thick like cream. To prepare it, stir the ink stick in
water on the ink stone until the ink ceases to run. Chinese
painters who want to achieve a special velvety charred ink
grind it the day before painting, so that some of the water can
evaporate to produce the desired rich texture. The other four
shades are produced by adding progressively more water to
the ink.

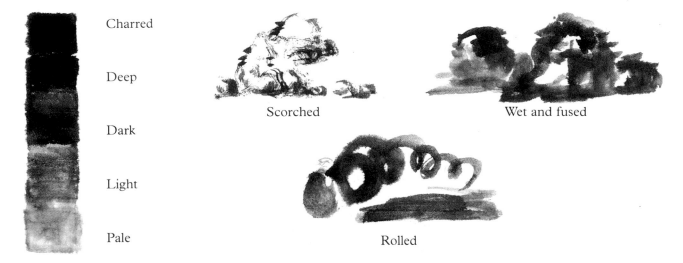

Charred

Deep

Dark

Light

Pale

Scorched

Wet and fused

Rolled

The five grades of ink blackness, and how to use them

In addition, different uses of the brush will produce scorched, wet and fused, and rolled ink effects.

SCORCHED
For the scorched effect a dry brush is required. Soak the brush in water, then remove most of the water by pulling the brush through absorbent paper once or twice until the desired degree of dryness is obtained. Dip the brush tip very lightly in the ink, and you will be ready to make the scorched brush strokes.

WET AND FUSED
For these strokes more moisture must be applied. Dip the wet brush tip in the ink before making brush strokes.

ROLLED
The aim here is to produce a continuous rolling effect to represent clouds, waves or fast-flowing rivers. Dip a large brush into light ink, then into deep black ink. The effect is achieved with quick, short brush strokes.

Brushes

執 筆 法

Both painting and calligraphy are executed with brushes of varying sizes. Chinese brushes are rarely graded in numbered sizes, so throughout the text I have referred to them as 'very small', 'small', 'medium' and 'large'. You can also use ordinary sable hair watercolour brushes: see the chart below for comparative sizes.

Chinese brushes	Sable hair watercolour brushes
Small	Nos 1–7
Medium	Nos 8–10
Large	Nos 11–16

Each brush is very adaptable and can be used to create different effects on the paper; this ability is very much a result of the way in which the brush is held.

How to Hold the Brush

The brush can be held vertically or obliquely, but the grip remains the same. It is not always easy to learn the Chinese way of holding a brush, especially if you are used to the Western way, but it is a technique that has to be mastered if you are to realise the full potential of the brush.

1. Sit up straight.

2. Now relax.

3. Take the brush in your hand and hold it firmly either in the middle or at the top, and vertical to the paper. Make sure your wrist is perfectly relaxed, and not in contact with the paper or any other support.

4. Your hand should form a hollow, large enough to hold an egg, under the fingers that are gripping the brush.

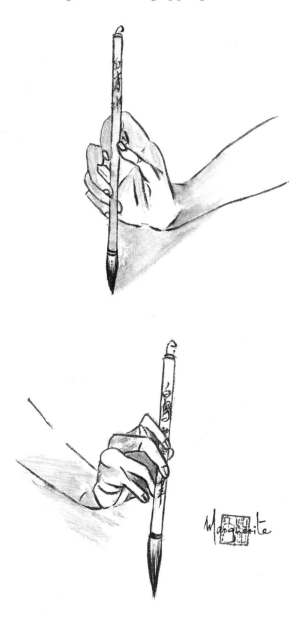

The correct way to hold the brush

How to Use the Brush

Different effects can be achieved, depending on which part of the brush is being used, and in what way. A number of techniques are described below, and others will be encountered throughout the book.

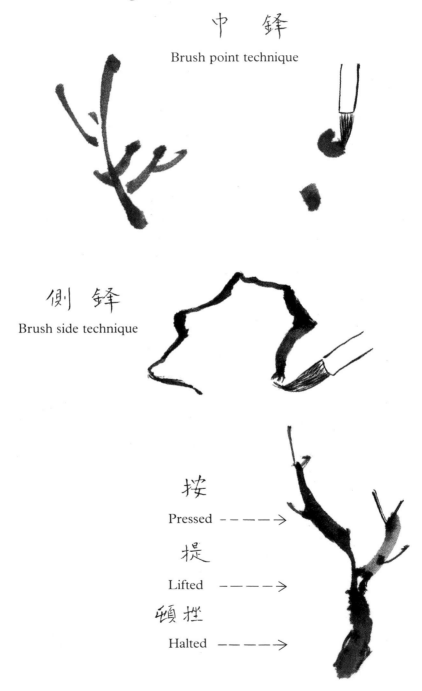

中 锋

Brush point technique

側 锋

Brush side technique

按

Pressed - - - - →

提

Lifted - - - - →

頓挫

Halted - - - - →

Ways of using the brush

THE TWO STYLES OF CHINESE PAINTING: OUTLINING AND IMPRESSIONISTIC

There are two basic techniques in Chinese painting: the outlining method (also known as the elaborate or Gongbi style), and the non-outlining method or impressionistic style (sometimes called freestyle or Xieyi).

For the former, artists use only lines to suggest form and texture. They draw the contour of the subject in ink, then apply colour washes within that outline.

For the latter, bold brush strokes are freely applied to express rhythmic beauty. Colours, as well as ink, may be applied dry or wet, in a single layer or in a number of layers, to produce a wide variety of effects.

WET UNDERPAINTING

This process is done after drawing an outline in ink and letting it dry. Wet the paper with clean water, using a piece of absorbent paper to soak up any excess. Then apply colour while the paper is still damp. Use another clean brush to smooth the painting strokes if required.

RUBBING AND BRUSHING IN

These two methods, used for painting rocks and birds' feathers, are done with a practically dry brush – the Chinese call it a 'thirsty brush'.

Dip the brush in water and then squeeze it almost dry in a tissue. Now dip the brush into some very thick colour. Use the side of the brush for rubbing and the tip for brushing by twirling and pressing on to the paper. This technique, often known as 'dry-loading', can also be carried out with black ink.

Rocks and Mountains

石

There is an ancient Chinese saying: 'Consider the three planes in painting a rock'. The 'three planes' are the front view and the two sides. To the Chinese, rocks also have a spirit – without spirit, rocks have no life.

Various brush strokes are used when painting rocks. Here are some general guidelines.

Start with the outline of the rock, using a dry brush and ink. Roll the brush gently with your fingers, making breaks in places according to the form of the rock. Unless you are painting a particularly smooth rock, the outline should generally look rugged. One side should be darker than the other, to make the distinction between light and shadow, back and front.

Paint the divisions in the rocks with a few strokes only, to show the general structure. Using slightly overlapping parallel lines, add a wrinkled effect in the shadows. Always shade from light to dark. Hold your brush at a slant, with the tip barely touching the paper at the beginning of each stroke. As

大斧小斧
劈法

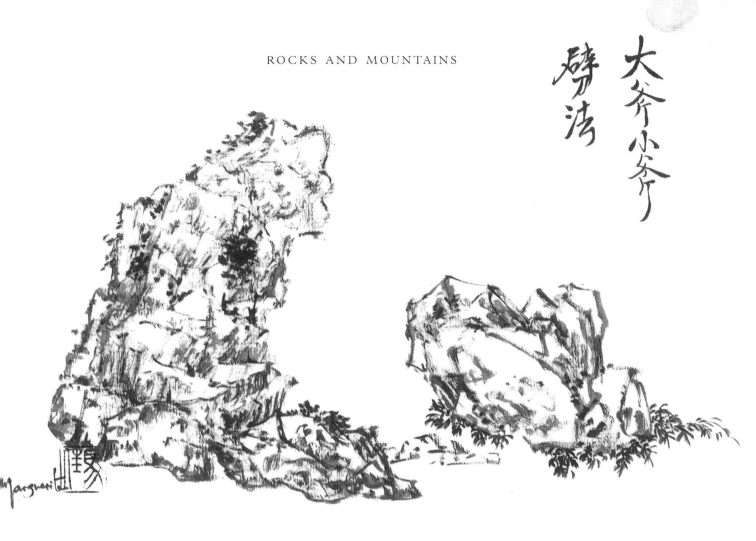

Rocks, scrub and undergrowth

it moves down the paper, the brush stroke broadens out.

To give more tonal variations to the rock, apply washes with a very light, diluted ink. Alternatively, apply a colour wash. Use red ochre for the lighter parts, and while it is still wet apply indigo to the shaded parts. Let these two colours blend naturally.

Either before or after the washes, dots can be added to indicate moss or lichen growing on the rock. Hold the brush upright and dip the tip into black ink, then let the brush make irregular and slightly overlapping groups of dots.

23

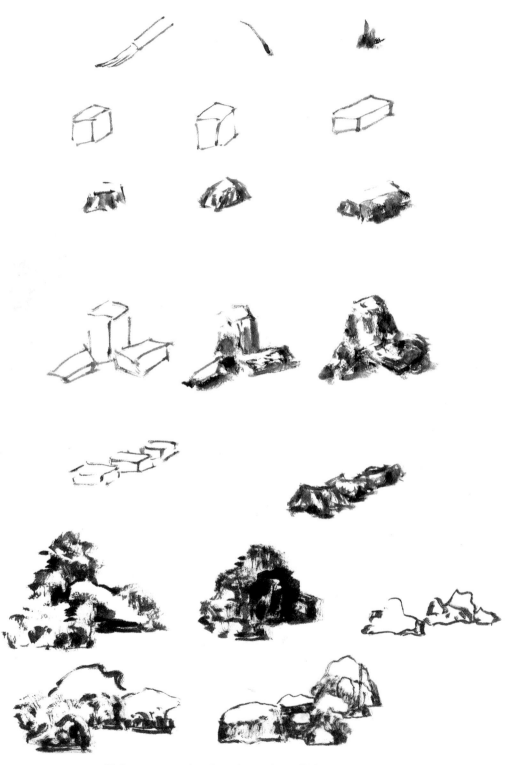

Using appropriate brush strokes, Chinese-style
rocks covered in vegetation can be built up stage
by stage from simple three-dimensional shapes

From Rocks to Mountains

Once you have mastered rocks you can go on to paint mountains. But a mountain landscape is more than just a group of rocks. Your composition will need light and shade – in other words, a degree of variation to create interest. The Chinese talk about appropriate groupings of mountains as having a 'host-guest relationship'.

You will find more about landscape painting on page 107.

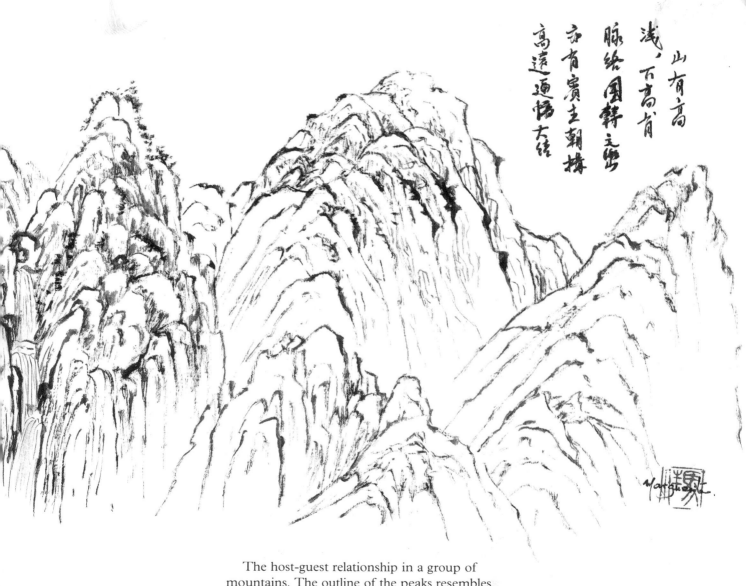

The host-guest relationship in a group of mountains. The outline of the peaks resembles veins. The view of a sheer mountainside from a low viewpoint is called 'high distance' and is explained on page 110

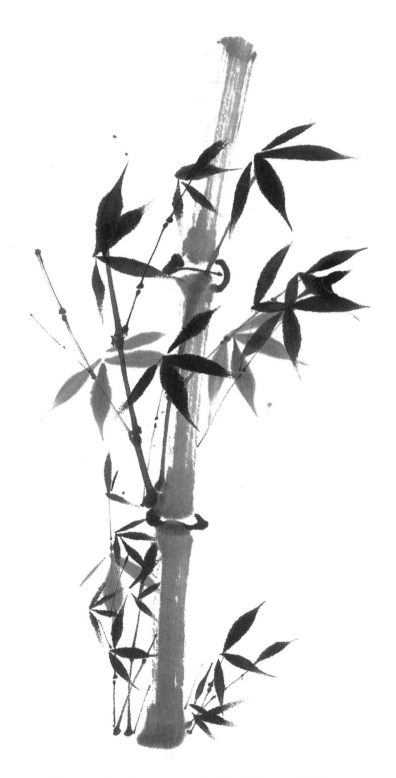

Bamboo is a frequent subject in Chinese painting,
both alone, as here, or as an element in a
landscape

Bamboo

竹

Bamboo is an essential element in Chinese landscape painting. To Chinese scholars it symbolized an upright yet humble man who could adapt to adversity and change without sacrificing his integrity.

The plant grows very straight, and is hollow inside. So when you are painting bamboo you should make each stroke with a vertical brush. This requires a strong, decisive arm movement.

A painting of bamboo demonstrates the close relationship between painting and calligraphy: the same brush can be used for both. In both cases the work must be executed in a single flow, without hesitation or revision.

Elaborate Style (Outlining Method)

To paint bamboo in this style, first fill in the outline in ink. Then progress to the leaves. These may be done either in ink or in indigo – darker near the joint, and lighter towards the tip. Colour may be applied in two or three layers to produce subtle tonal values.

To paint the stems, add yellow to green. Make the joints darker.

Bamboo shoots require a shading of light ink first. Let it dry for a while, then add colour.

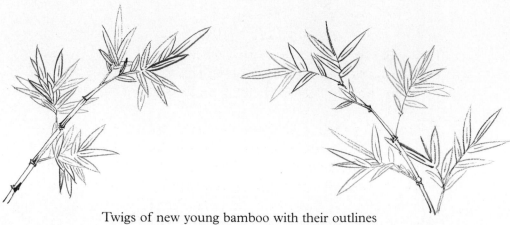

Twigs of new young bamboo with their outlines
filled in with ink

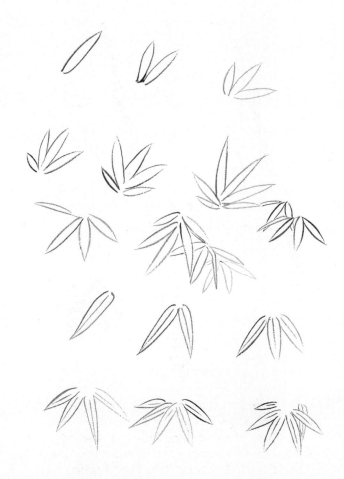

Bamboo leaves in the outlining method. The new
young leaves are all pointing upwards and looking
lively (TOP), while the more mature leaves
(BELOW) are pointing sideways or downwards

Impressionistic Style
(Non-Outlining Method)

First paint the main stems, using indigo mixed with gamboge yellow to produce shades of green. The young twigs, however, are a brighter colour, so use green added into emerald.

Next paint the leaves. Soak the brush with ample ink. At the start of each stroke, press the brush down firmly. When you have completed about two-thirds of the stroke, raise the brush gradually to form a bayonet shape.

Whichever method you use, note that the small branches grow from the knots on the main stem on alternate sides.

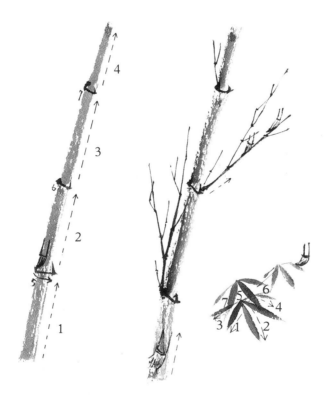

LEFT A bamboo shoot in the impressionistic style, showing the order and direction of working.
CENTRE A shoot with small side branches.
RIGHT Painting bamboo leaves, again showing the order and direction of painting to achieve a natural effect. Moisten the brush in water first and then dip the tip into the ink. Paint the stem in a succession of vertical strokes from the bottom upwards. Each segment of the stem is divided from the next by a node

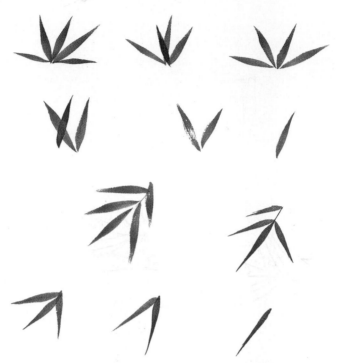

New (top two rows) and mature (bottom two
rows) bamboo leaves in the impressionistic style

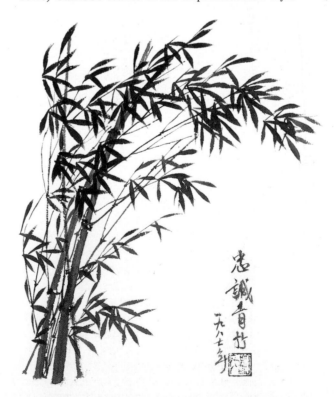

Bamboo bending in the wind (impressionistic style)

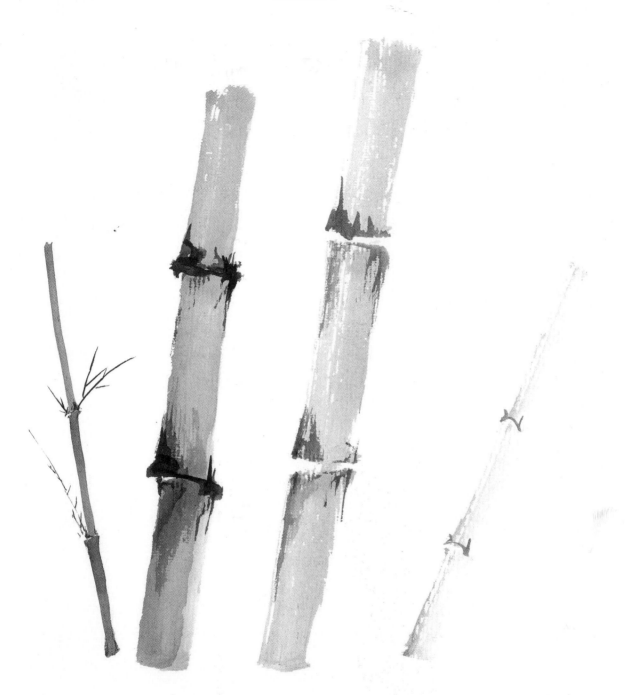

Bamboo stems in the impressionistic style. No
two stems should be painted exactly parallel
with each other. To paint a very big stem, use a
correspondingly large brush. First moisten it in
water, then dip one side only of the tip in ink.
Paint the stem in a single stroke, indicating the
node at every joint with a horizontal stroke in
heavy ink

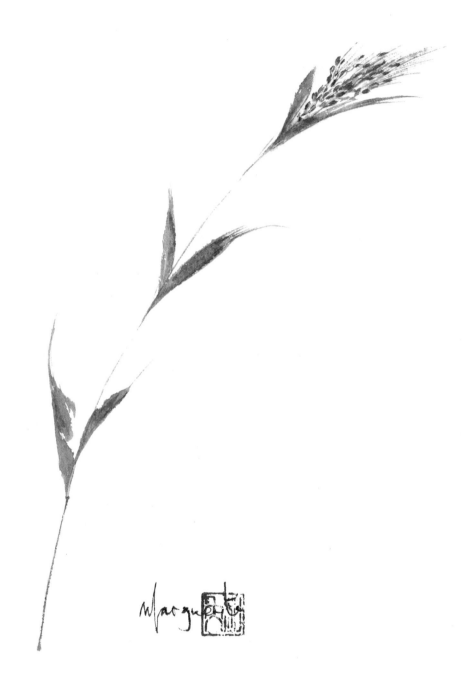

Flowering grass

Grasses

草

Grass is seldom the main feature of Chinese painting, but it is frequently used to enhance and complement compositions of flowers, birds and insects.

Here is the way to paint a flowering grass stem. First paint the stalk, using yellowish green and making it look like a thin, bendy piece of bamboo (see page 30).

For the leaves, use a slightly bluer shade of green. Leaves sometimes naturally twist, so that the underside faces upwards. The underside then appears pale and the tone must be painted accordingly.

Now to paint the flowers. Draw the stems with the point of your brush. Paint the seeds by pressing slightly with the tip of the brush – do the grey seeds first, then add one or two purple, yellow and white ones. The more white seeds there are, the riper your piece of grass will look.

If you are painting freestyle use a dry horsehair brush with its tip twisted, so that the end splays out slightly to give a split effect. Note whether the grass turns, as it always follows the direction of the wind. Paint the stems first and then the blades.

'Feathered' grass stem

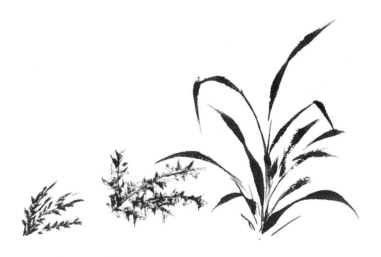

Grass and undergrowth of the kind frequently
found in the foreground of landscapes

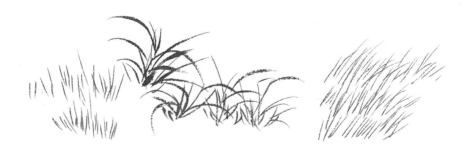

Three types of marsh grass

Trees

樹 譜

When composing a landscape painting it is important to know how to draw and paint trees. First draw the trunk and main branches, then outline the foliage with dots. Eventually, by following this method, you will be able to depict a luxuriant forest. Note carefully the way the branches relate to one another. If there are a lot of branches in nature, add more and elaborate them; where there are only a few, reduce the number.

In particular, carefully observe the structure and setting of the trees and the way they contribute to the whole composition. Once you are able to lay out the basic structure of a composition, the rest will follow and fit in happily.

Remember, just as a road branches off into other roads and paths, so branches fork out from the trunk. It is easy to find your way along a familiar road. You can travel its length, or branch off on to known side roads or even tiny tracks. You could probably even draw a map of this road network from memory, giving some idea of the angles at which various roads connect. Now you need to become equally familiar with the structure of different types of tree, so that you can depict them accurately.

Over the centuries terms connected with trees have become metaphors for various aspects of human life. Both tree

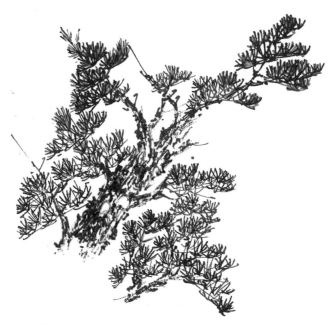

The pine tree is a symbol of longevity and of
constancy in adversity

branches and human legs and arms are referred to as 'limbs'.
We are all familiar with the tree of life, and we chart our
ancestors on a family tree. We use a branching diagram to
show the development of the human race. The tree has
therefore become symbolic of many aspects of our lives.

Many types of tree appear in traditional Chinese painting,
with all sorts of different leaves. Here is a selection of them:

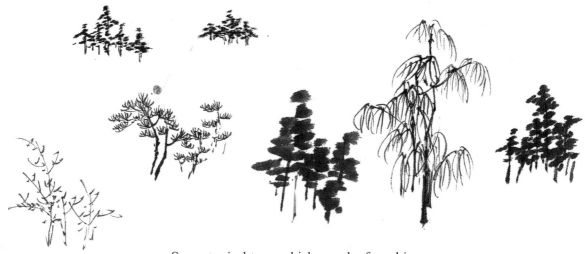

Some typical trees which may be found in
Chinese landscape painting

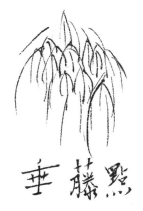

垂藤點

Weeping willow

梅花點

Prunus blossom

菊花點

Chrysanthemum

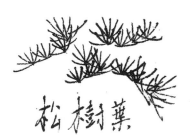

松樹葉

Pine leaves

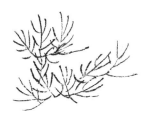

仰葉點

Willow

椿葉點

Tree of heaven

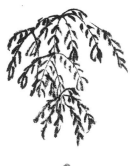

藻絲葉

Aquatic plants

Different kinds of leaves. Sometimes a
resemblance to other objects is suggested

Painting Pine Trees

松 樹

The pine tree is a symbol of longevity, which also stands for the constancy of friendship in adversity. It has needle-shaped leaves and gnarled branches.

Start your painting of a pine tree with the application of black and grey ink.

LEAVES

The needles appear in clusters, and tend to grow upwards from a branch (below left).

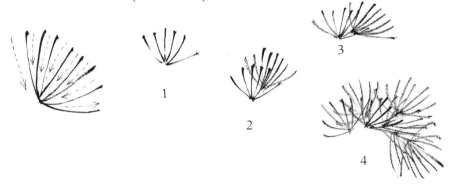

When painting pine needles, try to vary the angle slightly and overlap the groups of needles.

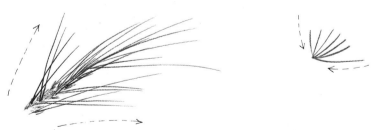

Overlapping pine needles at different angles to
create a naturalistic effect

BARK

Pine tree bark comes off in patches, like scales. To paint it you need a large dry brush and grey ink. Create shading by making rough circular shapes with the side of the brush. Do not make the circles too uniform, and only paint enough to cover about half the width of the branch or trunk. Towards the centre of the trunk make some semi-circles rather than circles. Do not shade the circles and semi-circles too neatly, or they will not look natural. Then apply the black strokes, using the tip of your brush and varying the pressure. The small side branches are painted like those of the prunus tree (see page 45), rugged and creviced.

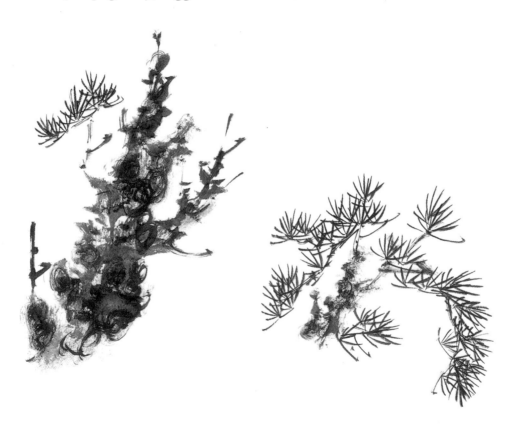

Painting pine trunks and branches: circles and
semi-circles create the effect of bark

ROOTS

To paint the tree roots, use grey ink first, then black strokes. Use a twisting motion.

Painting pine roots to give a twisted effect

CONES

Use black ink, with a flicking movement of the brush tip. Begin at the tip of the cone and work back towards the base.

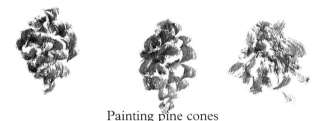

Painting pine cones

COLOUR

The trunk and branches need colour with a light wash. Use the whole of your brush and move it gradually over the desired area. Vary the tone as you apply the colour, and let the different shades blend together where they meet up.

To colour the needles, simply add a few green needles to the existing black ones. You can also add a few yellow or grey ones on one side of each group and some indigo ones on the other. This will give the impression of light and shade. Greater depth can be achieved by adding a very light green wash behind the needles after colouring.

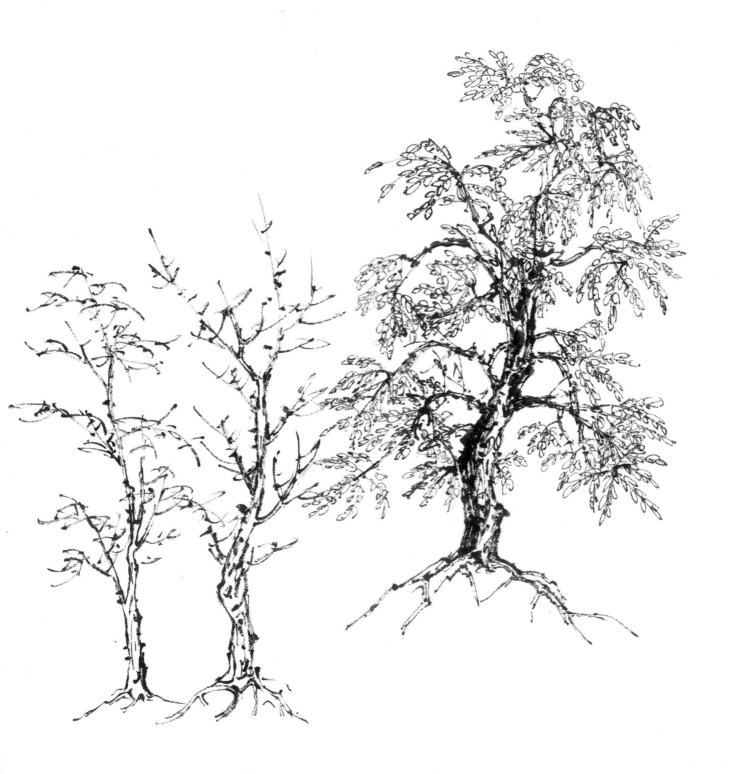

Gnarled trunks and twisted roots

Prunus Blossom

梅 花

The prunus tree (which the Chinese often call the plum) blossoms in winter or very early spring. It symbolizes a person who can stand the severity of the elements and who has a strong personality with a firm and indomitable will.

Prunus may be painted either in the impressionistic style or by the outline method.

Blossom

There are two kinds of prunus blossom, single and double. The flowers of the single kind each have five petals, while the flowers of the double prunus are multiple-petalled. Each flower head contains a number of stamens.

The flower may be white, green, pink, red or purple. To paint prunus blossom in colour, use diluted ink to delineate the outline of the petals before applying colour.

Paint the petals in flake white and then, if you like, add a little red on top. If you are using the impressionistic style, first soak your brush in flake white and then dip the point of the brush into pink, red or vermilion before applying it.

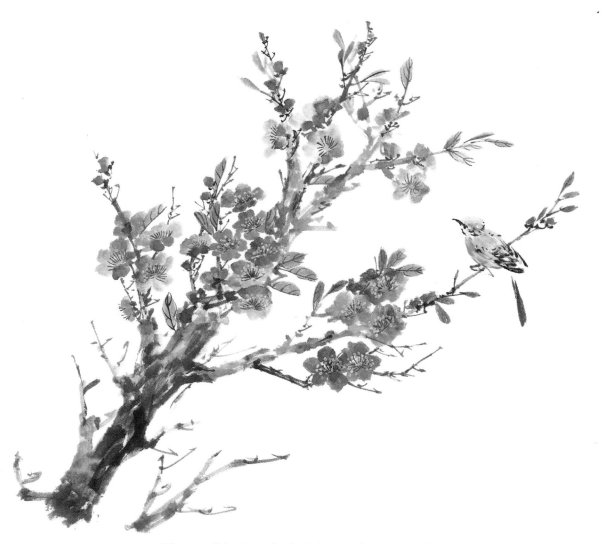

The small bird perfectly balances the composition
in this painting of a flowering prunus branch

Note that, in general, a petal is lighter when viewed from
the front and darker when seen from the back. Observe the
particular position of each blossom and see whether it faces
to the front, back, left or right. Notice also whether it is in the
light or it is in shadow.

When all of the petals have been painted, use some diluted yellow to wash out from the centre of the flower. This will help the colour to blend.

When the centre has dried, add the stamens in the centre of the flowers and then the calyxes around the outside of the base of the flowers. Stamens should be painted in a soft red or white, with their pollen-containing ends (anthers) dotted in pale yellow. The calyx of a white flower is dark green and that of a pink flower is dark red. Then add three thick dots in green or dark brown to make the inner base from which the stamens grow.

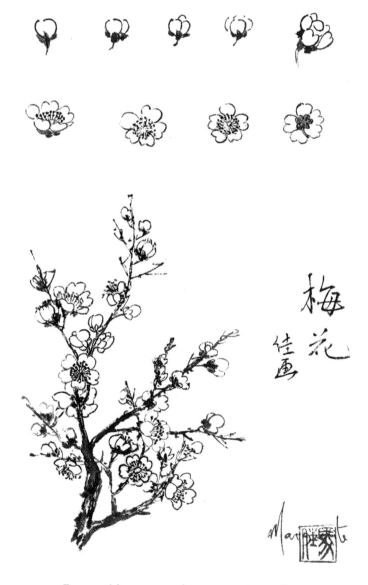

Prunus blossom: various stages in outline

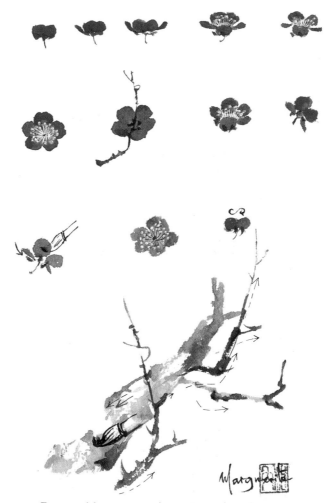

Prunus blossom: various stages in colour

Trunk and Branches

Prunus branches are gnarled and crooked, and fissures will be found in the bark.

For ink painting, start with the tree trunk and branches.

For the impressionist style moisten your brush in water. Dip the brush point into the ink and then paint on the paper. Paint the trunk first and then the branches, leaving enough space for the blossoms. The nearer branches will be darker in tone than those further away.

For the outline method, first draw the outline of the tree, and then apply diluted ink for the shading.

To paint in colour, again begin with the tree trunk and branches in ink in the manner of an ink monochrome painting. In the outline style, draw the shape of the tree, shade it in diluted ink, and lay washes over it in red ochre and green.

Further Tips

Here are a few more points about painting prunus trees which may be helpful.

When the trunk and branches are slender, the blossoms are small. But when the tips of the branches are fresh, the flowers are luxuriant. At the points where the branches fork off, the trunk flowers are numerous and mingle together. When there are only a few branch tips, there are also only a few flowers and buds.

The trunk should be drawn sinuously like a dragon, giving an impression of iron power. Tips of long branches are like arrows and short ones like spears.

Where there is space at the top of a picture area, indicate the top of the tree. But where there is little or no space, do not attempt to show the top.

If the tree is painted on a cliff or at the edge of water, its branches are curiously twisted and only bear a few blossoms. In fact, only buds and half-opened buds are seen.

If the tree is painted when it is looking wind-blown or rain-soaked there will be many spaces on the branches. The blossoms will be fully open, and many of them will be crushed and damaged.

If the tree is painted in a rising wind or after a slight snowfall, the branches bend, the tree seems old and there will be only a very few flowers.

If the tree is painted in mist, the branches should be delicately drawn and the blossoms depicted with tenderness, as though they held smiles and gentle laughter in the boughs.

If the tree is painted in sunlight, the trunk should stand proudly erect and the blossoms will seem as though they are giving forth a rich fragrance.

OPPOSITE PAGE Brightly coloured blossoms and an exotic bird, enhanced by the impressionistic style, create a feeling of tropical luxuriance

Orchids

蘭　花

Tropical orchids can grow in inaccessible forests, and so to the Chinese they symbolize serenity in obscurity; the orchid is also seen as an emblem of purity and virtue, whose perfume is highly prized. In Chinese art it is variously painted rising from the ground, or clinging to a rocky cliff.

When you paint orchids, you will need considerable practice on the leaves in order to depict their slenderness and twisting habit.

Orchids are often painted in ink, as described below, because of their elegant simplicity of shape. Coloured orchids are done in exactly the same way as with grey ink, but dip your brush either into black or into a darker tone of the colour you are using.

Flowers

The tip of the petal is a little darker than the centre, so dip your brush point first into grey ink and then into black ink. If you then start to paint a petal from the tip, it will naturally darken in tone as you approach the centre.

Start with the two central petals, (a) and (b) in the illustration overleaf. Pull the brush in the direction of the arrows.

Begin petal (c) at the centre of the flower. Pull the brush outwards, with just the tip in contact with the paper, turning

it slightly as you go. Then press the whole brush down briefly before tapering the stroke off the paper.

For petal (d), make the same movement in reverse, starting at the tip of the petal and moving back to the centre of the flower. The fifth petal (e) is vestigial and is done with a quick flick of the brush.

Up to seven petals may be added in this way.

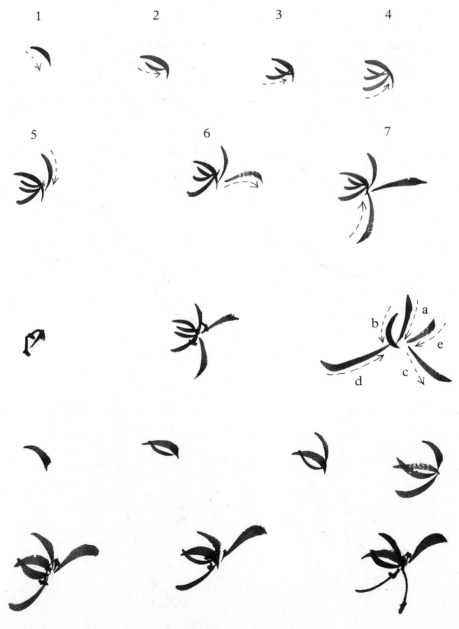

Building up petals on an orchid flower

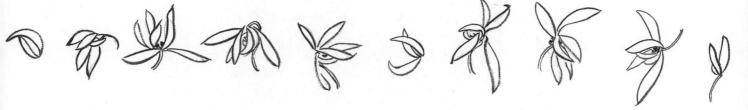

Different poses of orchid flowers, painted in the
outlining method

Leaves

Load the brush fully with grey or black ink (or a suitable
alternative colour). Paint the dark leaves first. Keep your
brush moving at the same speed throughout the stroke, and
vary the pressure, pressing down and lifting the brush off as
you go. Taper the end of each leaf.

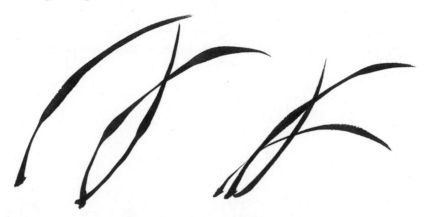

Steps in painting orchid leaves

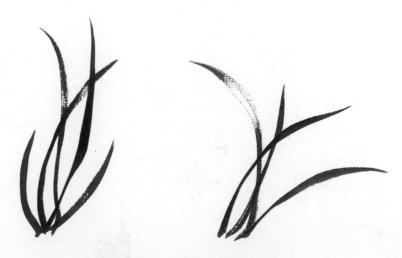

Arrangements of four and five leaves

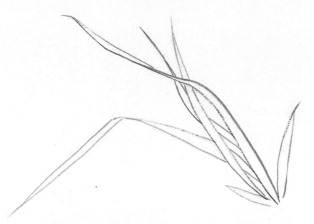

Orchid leaves done in the outlining method. First
paint two leaves crossing each other to form what
is called a 'phoenix eye' in traditional Chinese
painting terminology. Then paint the third leaf
growing in between, to 'break' the eye. Other
leaves can be added, as desired

Stem

Use light ink to paint the stem. It must be done quickly and
with good control. Pause slightly in order to make the joints.
Begin painting the stem at the top of the flower and work
down towards the roots.

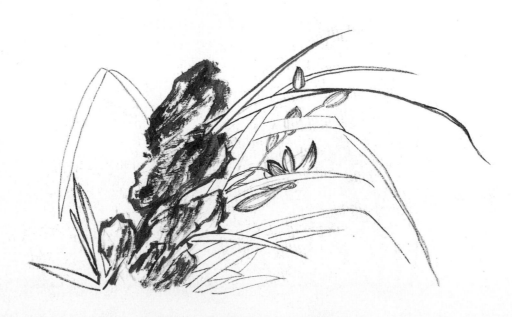

Orchids growing around a rock

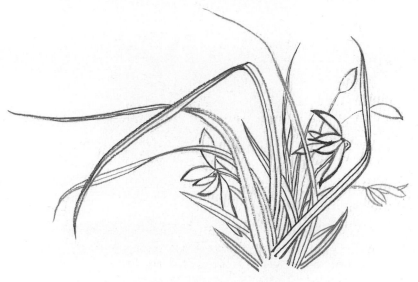

A clump of orchids outlined in ink

Roots

Do these with a twisting movement of the brush, using grey and black ink.

Stamens

When you come to paint the stamens, do them in black ink with a quick pushing movement.

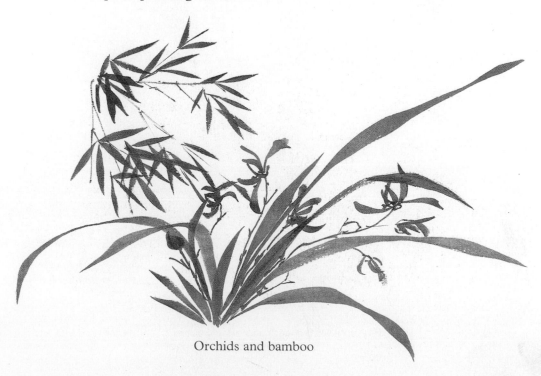

Orchids and bamboo

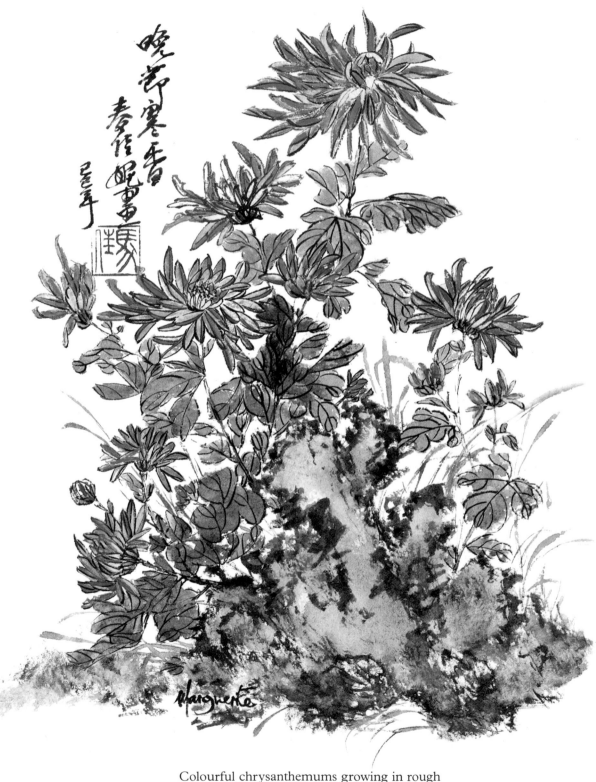

Colourful chrysanthemums growing in rough
ground

Chrysan-themums

菊 花

The chrysanthemum flowers in the autumn: when all nature is preparing for the long sleep of winter, the chrysanthemum comes forth from the soil in fresh and radiant colour. So this flower is seen to symbolize a person who can stand adverse environments without enmity to others, and who leads his own simple life.

Flowers
Start with the central filaments, and then paint the petals.

Order of painting a chrysanthemum petal

A chrysanthemum flower has many petals arranged in concentric rings, and the petals must be painted ring by ring.

The petals are darkest and smallest in the centre of the flower and become gradually lighter and larger as you move towards the outside edge.

For a yellow chrysanthemum, soak your brush with yellow. Then draw the petals on the left in 'W' shapes and those on the right in 'M' shapes.

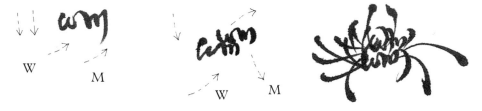

Building up a chrysanthemum flower with 'W' and 'M' shapes

The outer rings need to be shaded, for which you must load your brush in the following order. First soak it with a little white. Then add a touch of white and yellow on the tip. Finally take a little vermilion and yellow on the tip.

OUTLINING METHOD

Start by drawing the outline in ink and then paint in colour. The petal is painted with just two strokes, which form a tongue-shaped loop.

 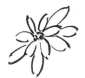 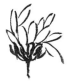

Two strokes form a tongue-shaped loop

The centre of the flower should be done in a light green wash. When this is nearly dry, apply firm dots of thick white to indicate pollen.

The calyx forms a kind of cup surrounding the outer base of the petals. Paint it with a green overlay.

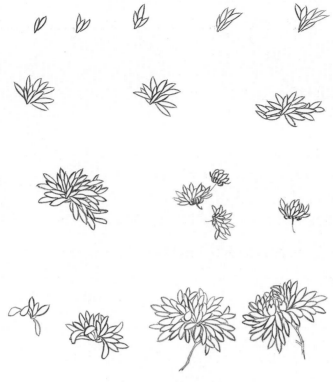

Chrysanthemum petals and flower heads in the
outlining method

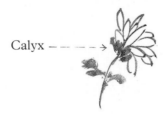

Calyx ‑ ‑ ‑ ‑ →

Chrysanthemum flower, showing calyx

Leaves

For the leaves, use a no.4 brush with between three and five
strokes, according to the size and shape of the leaf.
Remember that the upper surface is black, while the lower
surface is green.

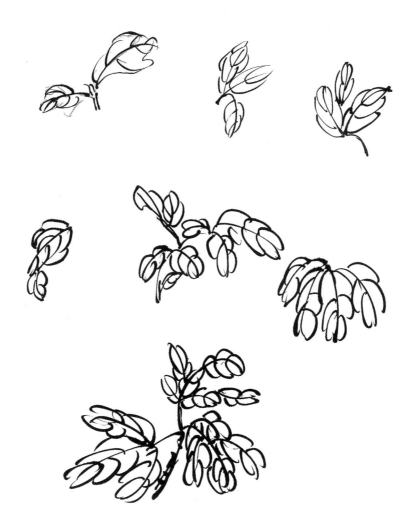

Chrysanthemum leaves in the outlining method

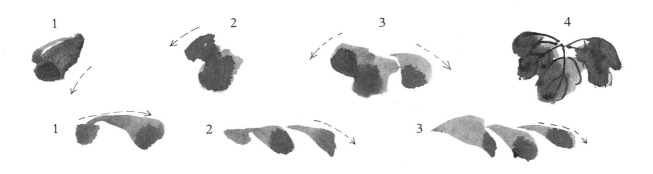

Stages in painting a chrysanthemum leaf

The leaves near the flower should be smaller in size, with darker shades in front and those further away gradually becoming lighter (see frontispiece). This will create a sense of depth in the picture.

Stems

The flowers cover the leaves, which in turn cover the stems. The main stem is supple but strong, its base old-looking, and the side stems young and tender-looking.

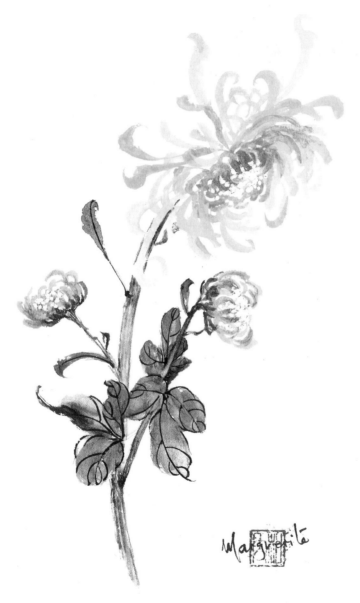

Yellow chrysanthemum

Peonies

牡丹花

The perennial peony (not to be confused with the tree peony) is regarded by the Chinese as the king of flowers, representing nobility and wealth. Its flowers can be white, yellow, pink, red or purple.

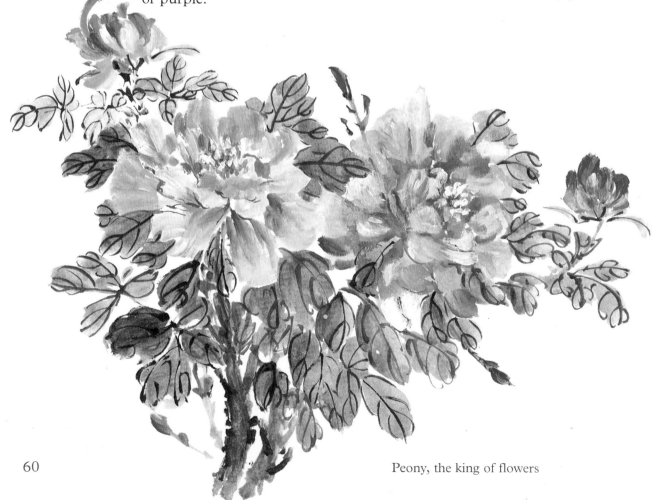

60

Peony, the king of flowers

Flowers

OUTLINING METHOD

Begin by lightly marking in the centre of the flower. For a half-open flower, lightly outline the sepals (the green leaves that form the cup-like calyx outside the base of the flower) in green before you put in the petals. For both half-open and completely open flowers, work from the centre of the flower outwards and use a darker tone of the colour you are going to paint them.

When colouring the petals, remember the following useful points. Always blend from light to dark. If you want a very

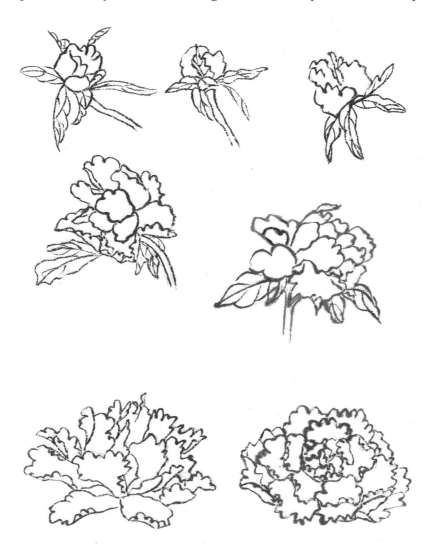

Peony buds and flowers in the outlining method

61

pale flower, fill the petal with white colour. When you are painting the base of the petal or round the edge, dip the brush in a darker shade, place the brush so that the tip comes where you want the darkest tone to be, and run the darker colour over the light one.

Rinse and dry your brush and blend the tones together with a clean brush. Always finish one petal before going on to the next.

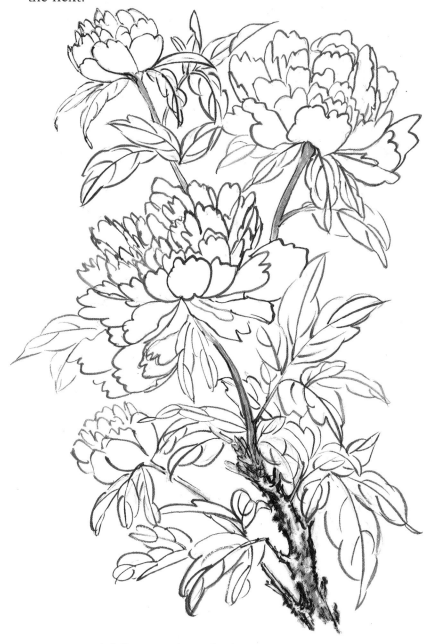

A full spray of peonies in the outlining method

IMPRESSIONISTIC STYLE

Use a large brush and saturate it in the lightest shade of the colour you have selected. Dip the brush about halfway up the bristles into a darker shade, then dip the very end of the brush into a still darker shade, and place the tip of your brush at the centre point of the flower. Press down the heel of the brush, moving the base sideways while keeping the tip still, then lift the brush off the paper.

You would never be able to see the bases of all the petals, so adjust the colours on your brush accordingly. On a side view, put the sepals in before the petals.

You can also blend in a little colour on to the edge of the petals in order to give the flower more shape. Load the brush as described above, but place the brush on the paper with the heel towards the middle of the flower. Then swing the darkened tip of the brush round to form the outside edge of the petal.

Stamens

Add the stamens with thick white (gouache white), and tip them randomly (to represent the anthers) using yellow, orange and red.

Stems

The main branches look sturdy, but the little twiggy ones seem delicate, with greenish ends connecting to the flower. They should be given an impression of lifelike movement, and not appear to be exhausted when they bend. They should cross each other, but not prop each other up when the stems are extended horizontally.

Leaves

OUTLINING METHOD

First draw the veins in very light green and lightly mark in the outline. Then apply the colour by blending in the same way as for the petals, starting by bringing a brownish tone in from

the outer edges and running fresher green out from the centre. You can draw the veins on again when the colour is dry, and enhance them by putting in a dark line on one side of the white or green vein.

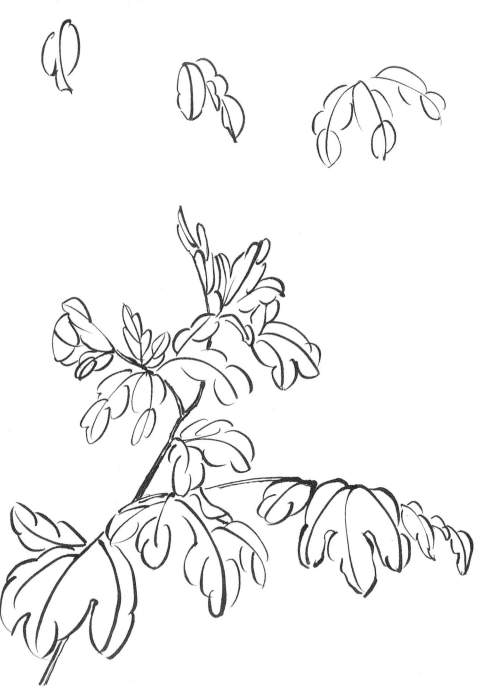

Peony leaves in the outlining method

IMPRESSIONISTIC STYLE

Use a large soft brush for the centre vein and build the leaf around it. Then fill in the intermediate segments and the side veins, or use two or three brush strokes to suggest its three extremities. Finally paint the veins into the wet brush strokes.

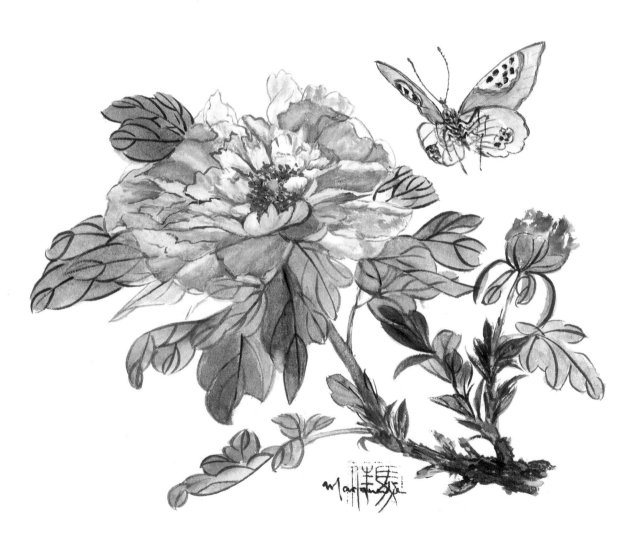

Peony and butterfly

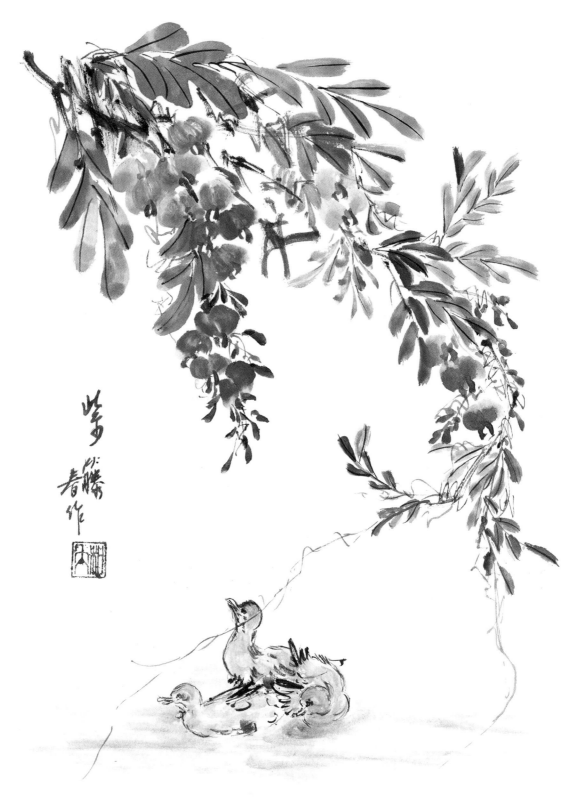

Wisteria hangs gracefully over a stream full of
young ducks

Wisteria

紫籐花

Wisteria is a climbing shrub with a large number of twisted, gnarled stems and delicate greenish leaves. Its mauve, pea-type flowers appear in spring.

Flowers

The two petals on the mature flowers are only tenuously attached. Paint them with a thin white, then with light purple. Now paint two deep purple blobs and fill the space between the petals with light yellow. When the paint is nearly dry, paint two thick yellow spots to represent pollen.

The flower buds should be painted in deep purple. The stems and the calyx are green.

Leaves

First paint a twig, lightly and faintly, then paint the older leaves in indigo and green. Finally do the young leaves in green and a tip of vermilion.

Stems

Paint the stems with a mixture of brown and a little black. The twining vines are done with inky red ochre.

Hibiscus

芙 蓉

There are two kinds of hibiscus, both of which bloom in late summer. One of them grows only in countries with a very warm climate, or in conservatories and heated greenhouses. The other, which has tougher, woodier branches, can be grown outdoors in temperate climates.

In both cases the flowers are usually pink, with several rings of petals. Each petal is prettily veined. The leaf has five points, and is shaped a little like a palm leaf.

To paint the flower, begin from the central petal. It is usually deeper in shade than the outer ones.

OPPOSITE PAGE A hibiscus twig done in the impressionistic style. Use light diluted ink for the flower and darker ink for the leaves. The veins on the petals and leaves are painted in while the ink is still wet

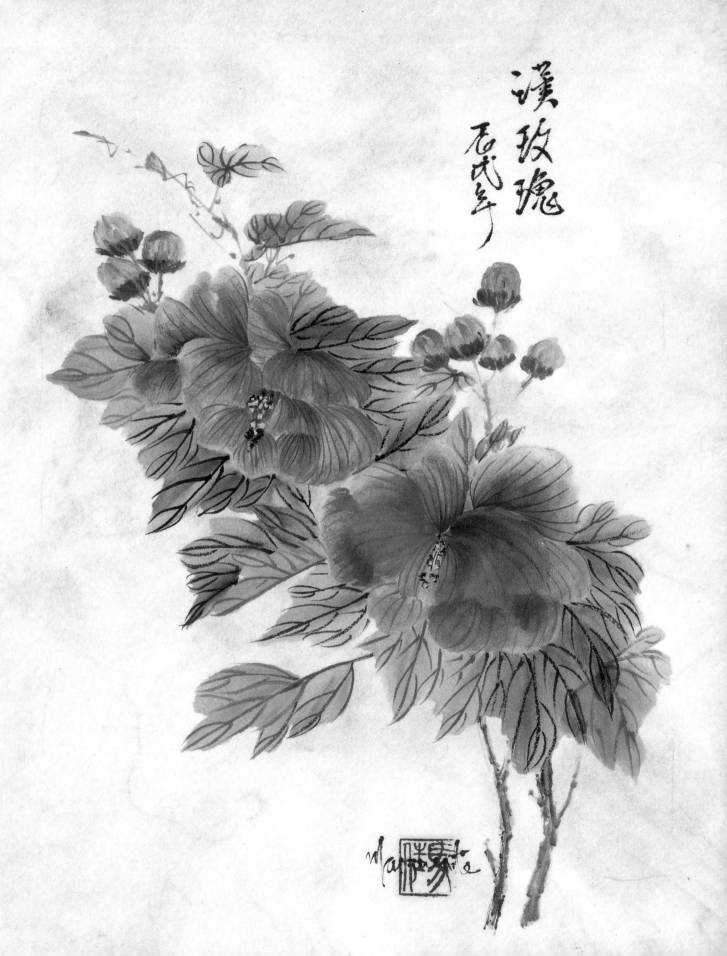

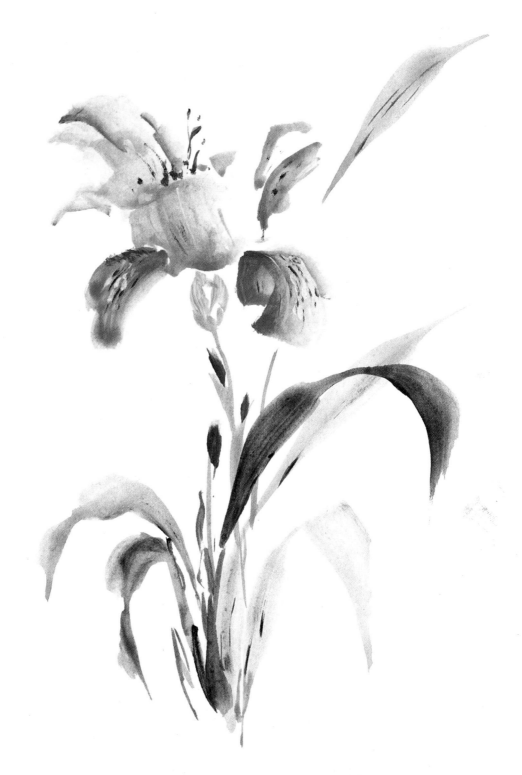

The dots and markings on the petals of this iris,
and the yellow pollen dots, are added while the
paint on the petals is still wet

Irises

蝴 蝶 花

The iris has showy, six-petalled flowers which range in colour from white through yellow and all shades of blue and mauve to deep purple. In a mauve iris, the centre of each petal is partly yellow. Three of the petals are brighter than the other three, and they are arranged alternately.

To paint the petals use a small brush. First soak it with diluted white, and then with a suitable quantity of violet. Holding your brush at a slanting angle, complete each petal in just two strokes.

The leaves are green, although the inner side of each leaf is much darker than the outer one. When you paint the inner side, blend ink with dark green colour to emphasize the contrast with the lighter side. Always paint each leaf in a single stroke (see page 10).

Narcissi

水 仙 花

The narcissus is a pretty, delicate flower which appears in spring. It has serenity and purity of character, and is one of the favourite flowers of the Chinese for their New Year celebrations.

When painting a narcissus it is very important first to work out the composition. The long, slender leaves add life and movement to the flowers.

Do the leaves first, then the flowers. Take a small brush, dry-loaded with light ink, and use upright brush strokes. Outline the leaves and then the flower, bulb and roots. Emphasize the outlines with fine strokes in a darker tone.

To paint the leaves, use a very small brush wet-loaded in two or three tones. Paint each leaf with one long upright or oblique brush stroke. Add in the slim vein before the paint is dry.

To paint the petals, first use a light tone. Then dip a dry brush into a dark tone and, pointing the brush tip towards the centre, press the brush gently on to each petal. Use an orangey red for the central trumpets of each narcissus and dot the stamens with yellowish white.

To paint the bulb, use a very small brush dry-loaded in dusty brown and dip the tip of the brush into dark ink. Hold the brush in an upright position and, with the brush tip

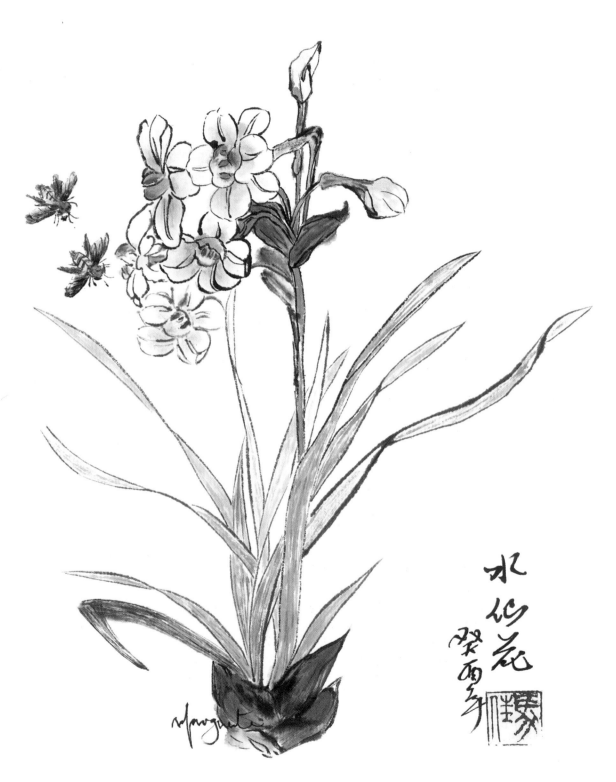

The delicate, waxy narcissus flower symbolizes
good fortune

pointing towards the root, gently press the brush to form wash scales on the bulb.

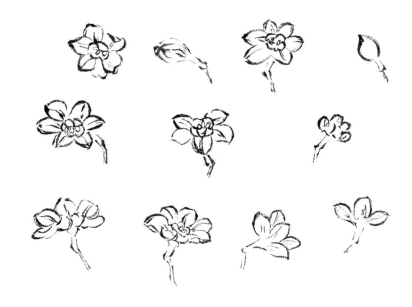

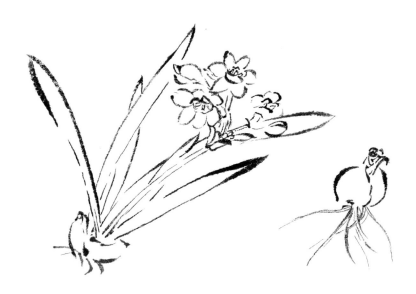

Outlining narcissus buds, flowers, leaves and bulbs

Birds

崔 鳥 畫 法

Basic Anatomical Details

First, it is necessary to understand a little about how a bird is constructed. There is a Chinese saying which runs: 'To paint a bird, do not go away from the form of an egg.' So an egg shape (1 in the illustrations below) is the starting point. At one end of the egg add a small circle (2), then at the other end add a basic tail shape (3). Divide the egg shape into three cross-sections: the legs naturally attach to the third of these divisions (4). Cut the egg shape into five equidistant divisions (5): the wings fall naturally into the upper three divisions, while the breast and belly belong in the lower two. Add a few feathers to make it more lifelike, and you will have a perfectly proportioned bird (6).

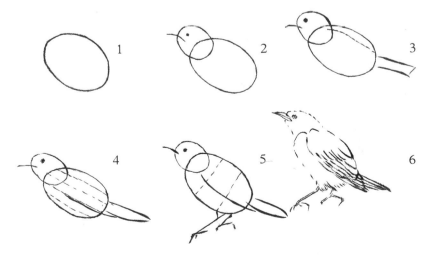

The basic form of a bird

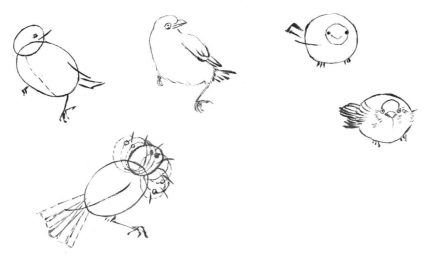

Typical bird postures

Painting Small Birds

Start by drawing the beak: outline the top, then add the lower portion, all in black ink with a fine-pointed brush.

Secondly, paint the eye. Use light ink for the eyelids, and very dark ink for the pupil. Note that birds of prey have their eyes much closer to their beak than other kinds of birds do.

Now lightly outline the forehead and the neck with a feathered brush, using grey ink.

Paint the wing feathers with a bamboo stroke. Then pick up your feathered brush again and use grey ink to paint the back.

To paint the breast, use a feathered brush with the predominant light colour and use the tip of the brush to add a darker tone with a dabbing motion, overlapping the strokes. (Note that the breast of some birds is better painted with bamboo leaf strokes.)

Lastly, put in the tail and legs and claws. Blend in colour from light to dark, and add a touch of white to the eye to bring it to life.

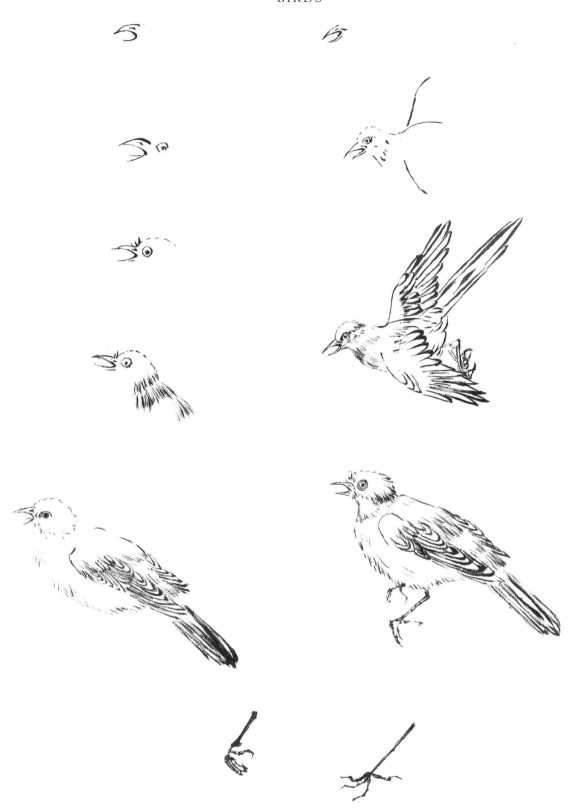

Stages in painting a small bird

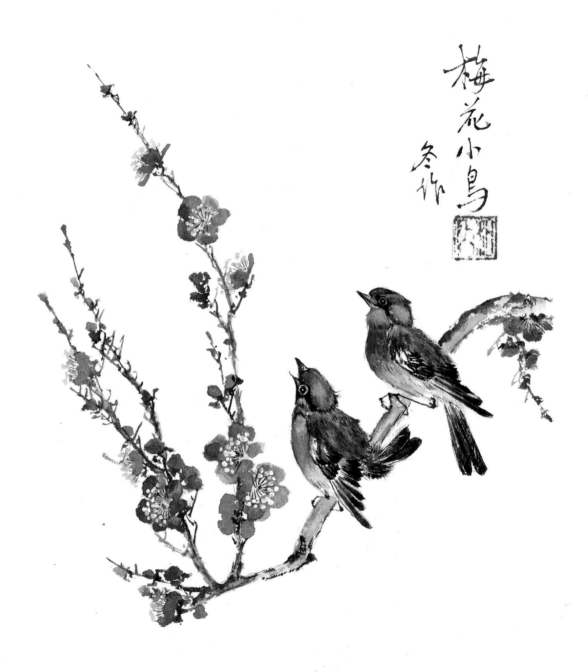

Little birds and prunus blossom in the winter

Painting Large Birds

The method is basically the same as for small birds, but it must be followed in a more precise manner. For example, their feathers are painted in meticulous detail, and put in individually. Start by marking in the backbone in light ink. Using a small split brush, work outwards from the backbone with a feather stroke. Then reverse the stroke and feather inwards from the outer edge. Add a wash of the predominant colour of the bird, emphasize the backbone with black, and highlight the backbone and the edge of the feathers.

Birds in Flight and Other Activities

Going back to our original egg shape with its stylized head and the tail attached, draw a tangent to this body shape in order to fix the position of the wing (1 in the illustration on page 80). If the wings are raised, the tangent becomes an inverted angle (2). The small circle which suggests the head may move outside the egg shape if the bird tries to stretch its head. Move the small circle inside the egg shape to suggest a bird flying straight towards you.

Observe how the bird flies and sings, pecks (3) and eats. For example, a flying bird stretches its wings and tail, opens its eyes and closes its claws. When it lands, the claws are outstretched again (4). A bird rests with its claws holding fast on to a tree branch, and with its eyeballs turning on one side (5 and 6). A singing bird opens its mouth, and so on.

So remember, to make your painting of a particular bird even better, you need to study its characteristic shape, movements and lifestyle.

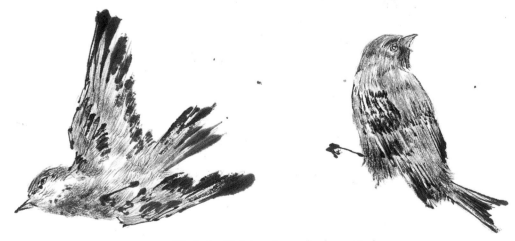

Birds in flight and perched on a twig

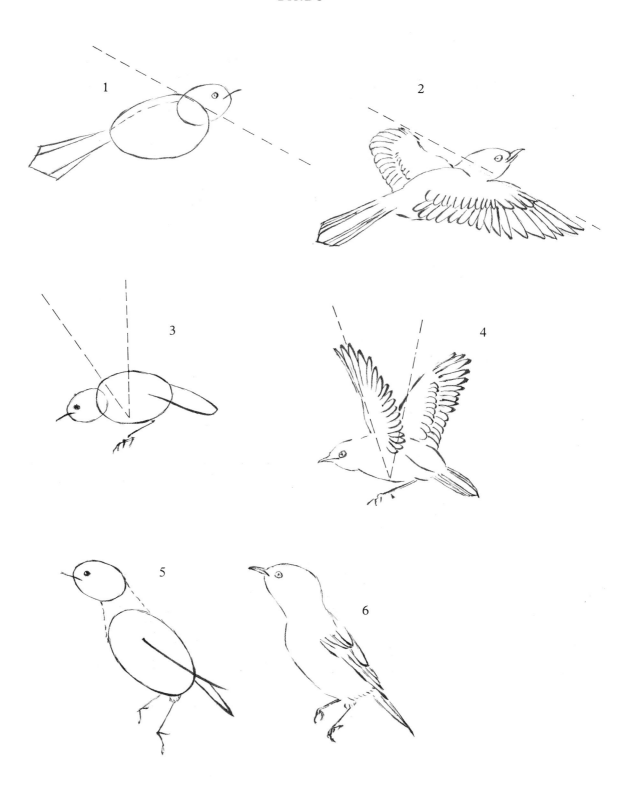

Birds in motion and at rest

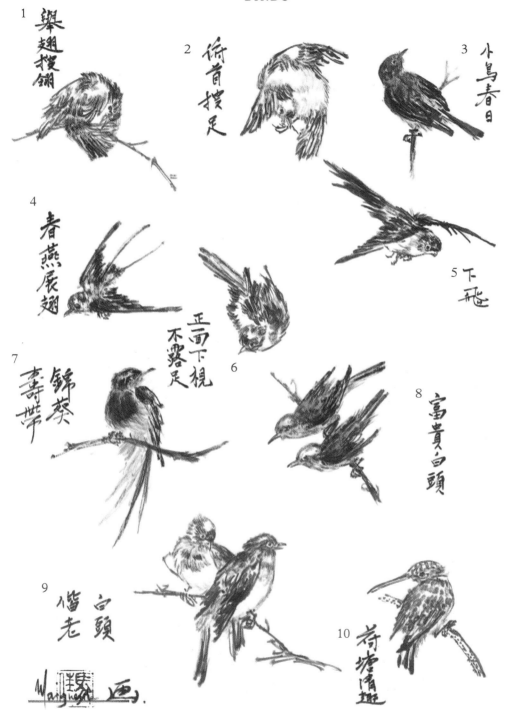

The lifestyle of birds:
1 With wing raised, investigating its feathers,
2 Head down, looking at its feet, 3 Little bird in
springtime, 4 Swooping swallow, 5 Flying
downward, 6 Front view of bird looking down,
7 Longevity, 8 Wealth and honour, 9 Growing
old together, 10 Kingfisher

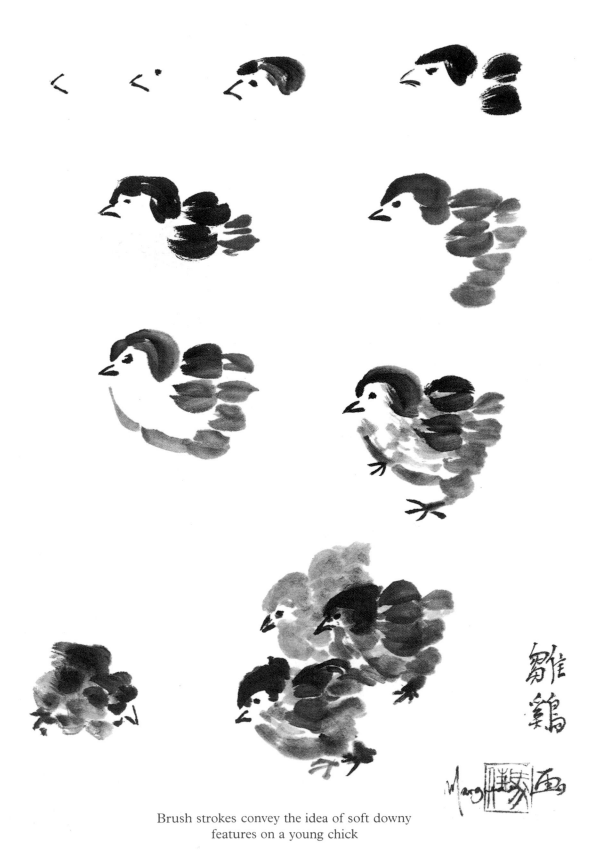

Brush strokes convey the idea of soft downy
features on a young chick

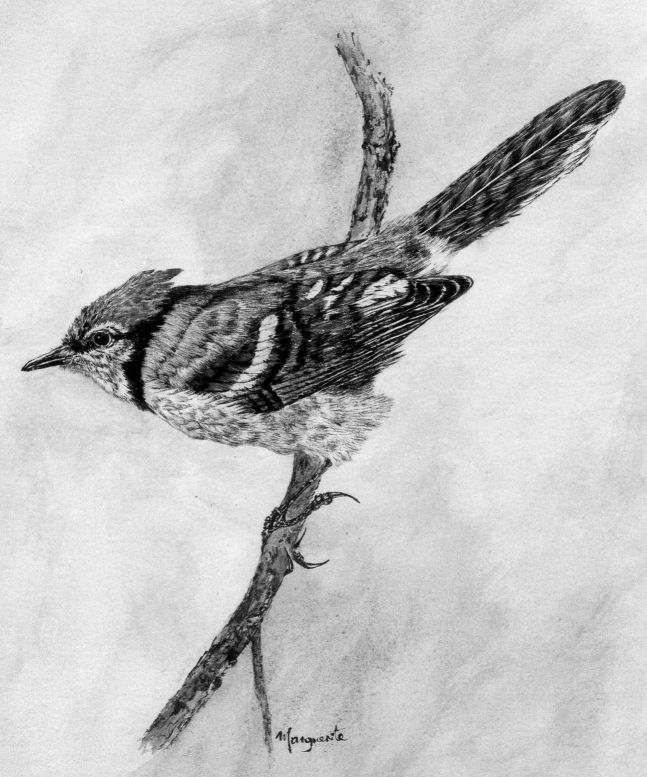

A brilliantly coloured jay. Note the way the claws
curl around the slender branch

83

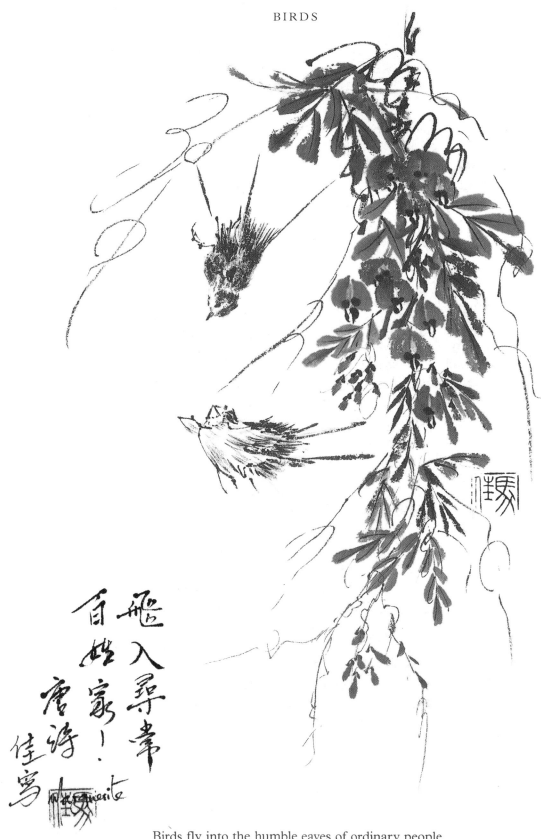

84 Birds fly into the humble eaves of ordinary people

Fish

魚 類 畫 法

A fish is the symbol of prosperity and fertility. In Chinese painting, fish are always painted swimming in the water, usually among waterweeds.

Catch the swimming poses first. Then you can start painting the details of the fish, beginning at the head, progressing to the body, and finishing with the tail.

Use light diluted ink to paint the head – the eyes, the mouth and the gill covers. Now add thick dark ink on the forehead and eyes as shown. Use very pale ink along the brim of the gill cover.

The back is done with dark strokes in three lightly curved sections. First soak your brush with light diluted ink. Then dip the tip of your brush into thick dark ink. Apply a few bold brush strokes to suggest the light and shade of the fish's body.

For the tail, use a wet-loaded brush. First soak it with light diluted ink and then dip the tip into thick dark ink. Hold the brush at an oblique angle to make a quick, firm, outward stroke to form the tail.

The fins, too, are painted with a wet-loaded brush. Press the obliquely held brush from the leading edge, and stroke outwards. Do each fin in a single oblique brush stroke.

To delineate the fins and tail, use a dry-loaded brush and darker tones. Flatten the bristles and paint quick, outward-

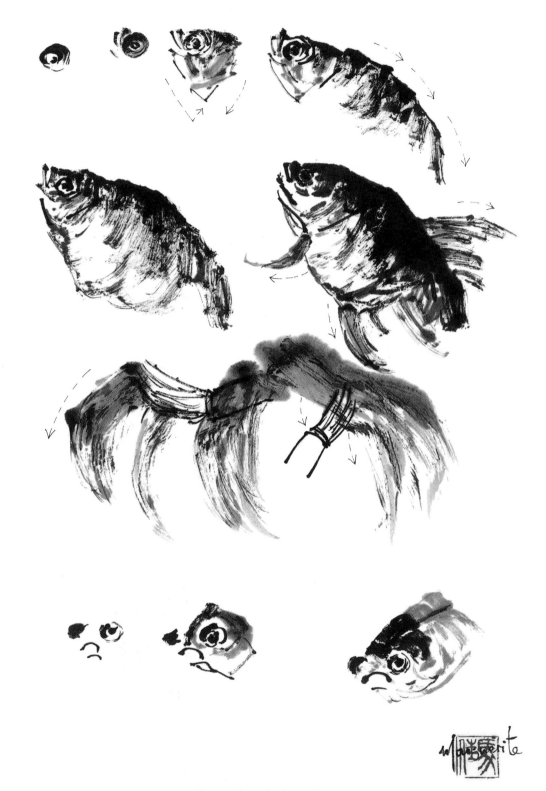

Stages in painting a fish

moving strokes. Start from the leading edge of the fin while the painting is still wet.

If you are adding water plants, paint them with the tip of a vertically held brush, using a medium tone of ink. Water plants are usually fan-shaped, and grow in clusters.

Colours can be used for washes, and applied either alone or mixed with ink.

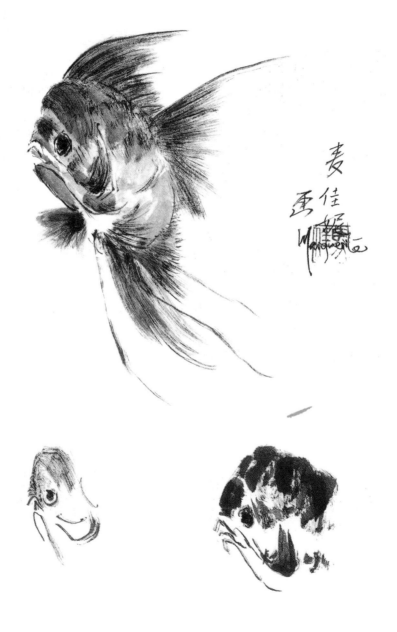

Deft brush strokes shape the fish's head and the feathery fins

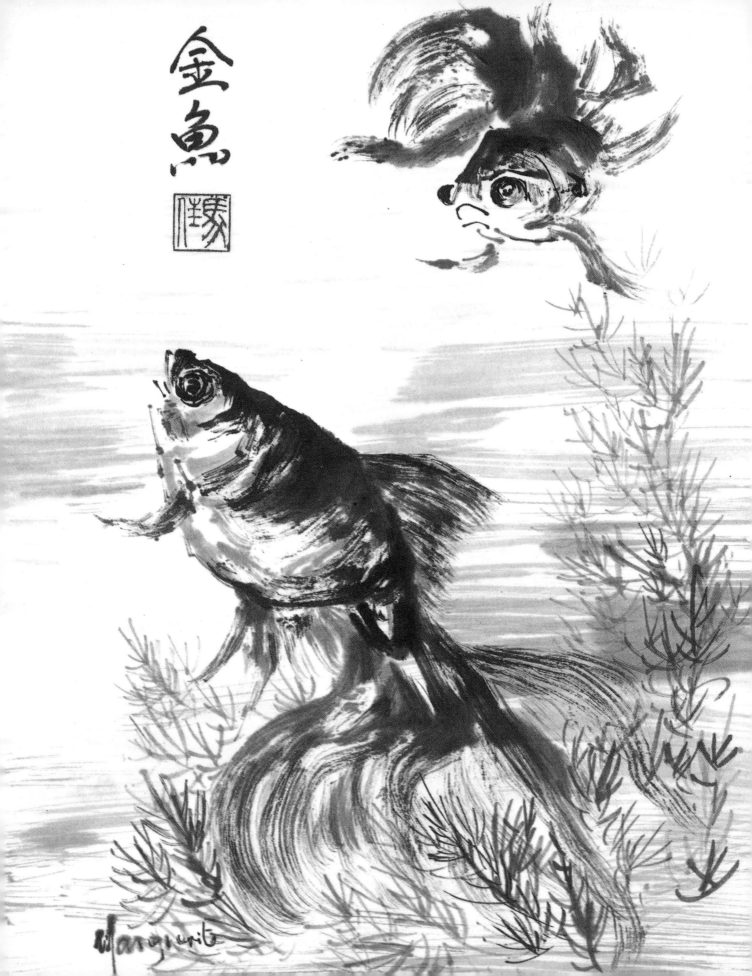

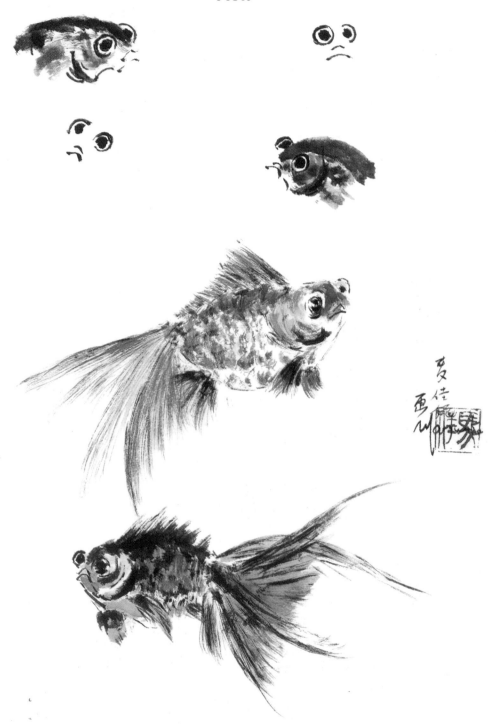

It is important to capture the protruding eyes
faithfully or the fish's expression will seem wrong

OPPOSITE PAGE Some oriental carp have
wonderful long, flowing tails which enable you to
make beautiful compositions in your paintings

Insects

草 蟲 畫 法

Ancient Chinese poets wrote of birds, animals, plants and insects, down to the smallest and most humble. They all bore some symbolic meaning. Painters, too, have always loved these small creatures.

In general, an insect has four wings and six legs. But beyond that there is infinite variation in colour, size, form and lifestyle. So when you are depicting insects pay careful attention to their appearance when flying, fluttering, chirping, hopping and so on.

When insects such as bees, moths and butterflies fly upwards, the body drops but the wings point upwards. And while in flight all the legs are pulled inwards to their body.

Chirping insects such as grasshoppers vibrate parts of their front wings against their haunches to make the sharp sounds with which we associate them.

Hopping insects have very strong hind legs and hold their bodies straight.

To paint a small insect, start with the head, then go on to the body, the wings and finally the legs. But if you are painting a butterfly or other large insect do the wings first and the other parts afterwards.

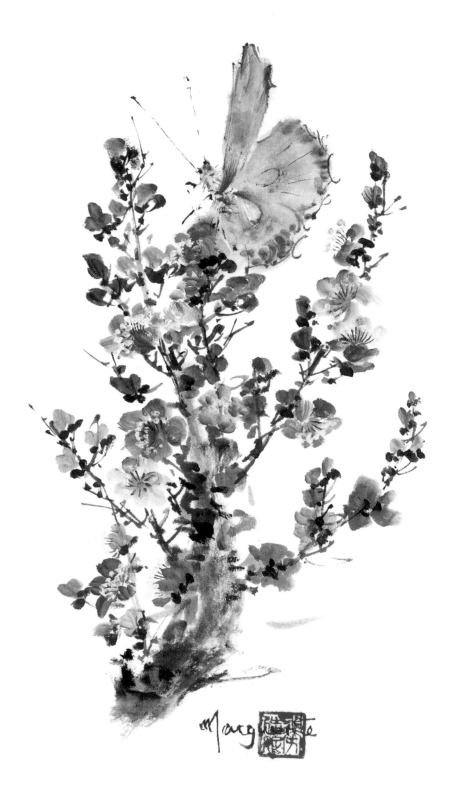

A butterfly alights on a branch of prunus so that
it can suck nectar

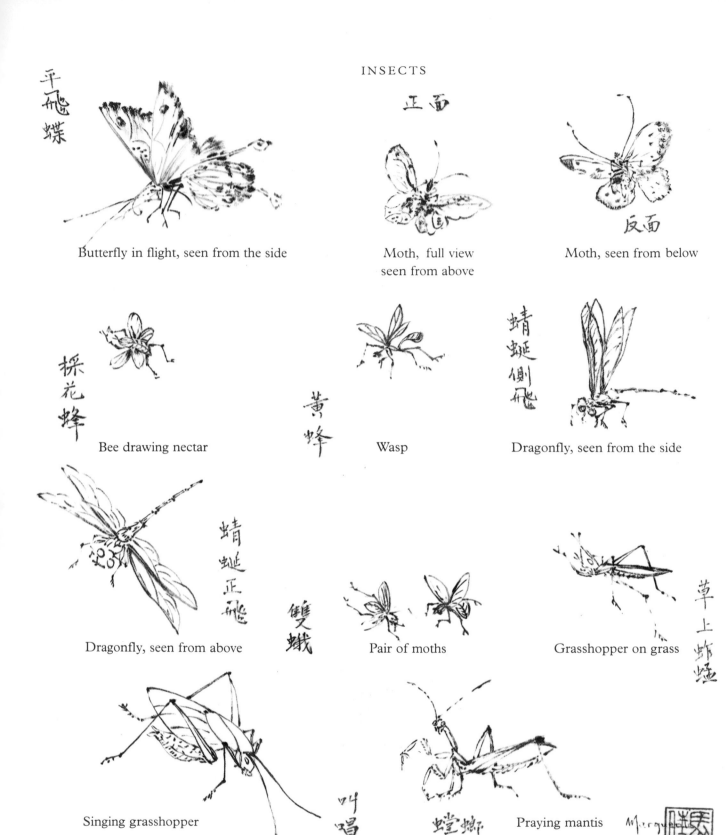

平飛蝶

Butterfly in flight, seen from the side

正面

Moth, full view
seen from above

反面

Moth, seen from below

採花蜂

Bee drawing nectar

黃蜂

Wasp

蜻蜓側飛

Dragonfly, seen from the side

蜻蜓正飛

Dragonfly, seen from above

雙蛾

Pair of moths

草上蚱蜢

Grasshopper on grass

Singing grasshopper

叫唱蜢

螳螂

Praying mantis

A variety of insects

Painting a Dragonfly

This is how to paint a dragonfly in impressionistic style, as shown in the illustration below. Do the head and body by taking the colours in the following order: vermilion, red, deep red. The face is green and the legs are brown. The wings are light blue with fine lines in a mixture of red and black.

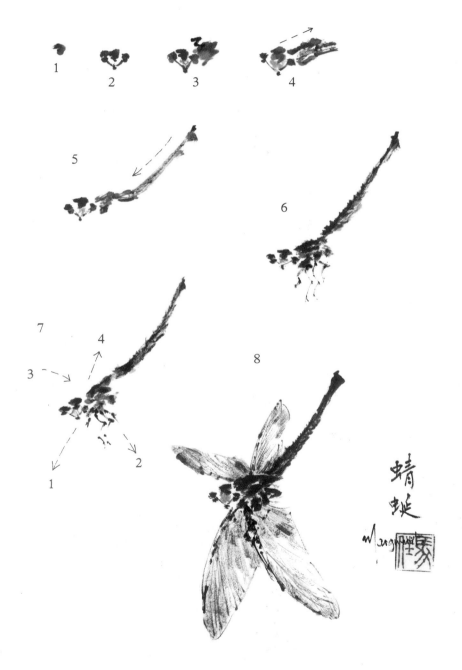

Stages in painting a dragonfly

Painting a Butterfly in Impressionistic Style

The butterfly, with its beautiful membranous wings in a host of colours from subtle browns and whites to brilliant reds and purples, is a symbol of joy and youth. Since the wings are the most visually important part of a butterfly, paint these first and use dark ink to delineate the various parts.

Butterflies' mouth parts consist of a long thin tube called a proboscis. When flying it is coiled up, but when the butterfly approaches a flower the proboscis extends to suck nectar and the wings close vertically.

WINGS

Use a brush wet-loaded in a light tone, then dip the tip of it into a dark tone. Hold the brush upright, with the tip pointing towards the body. Press down lightly and form the top wing in one simple stroke.

To form the lower wing, press the brush lightly and then rotate it to make a circular stroke.

When the wing is nearly dry, use a brush dry-loaded in a darker tone to apply some spots or designs. Use a light tone for drawing in the veins.

BODY

Use a brush wet-loaded in a light tone. Hold the brush upright at a slight angle to the paper, press down, and form a dot for the body and a long, curved stroke for the tail. Now take a dry brush and dip it into dark ink to draw the curved line on the tail. Then with a small brush dry-loaded in a dark tone, apply upright brush strokes to paint the antennae, eyes, legs and fine hairs on the abdomen.

Painting a Butterfly in Outlining Method

First outline the body. When this is dry, apply the wash. Draw in the rest using a brush dry-loaded in a dark tone.

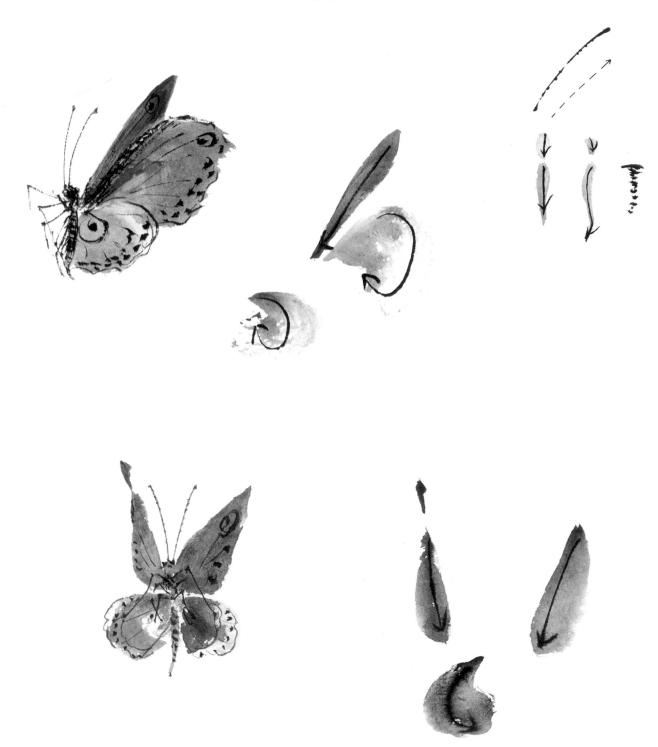

Painting a butterfly. The lower wings are formed
with circular strokes

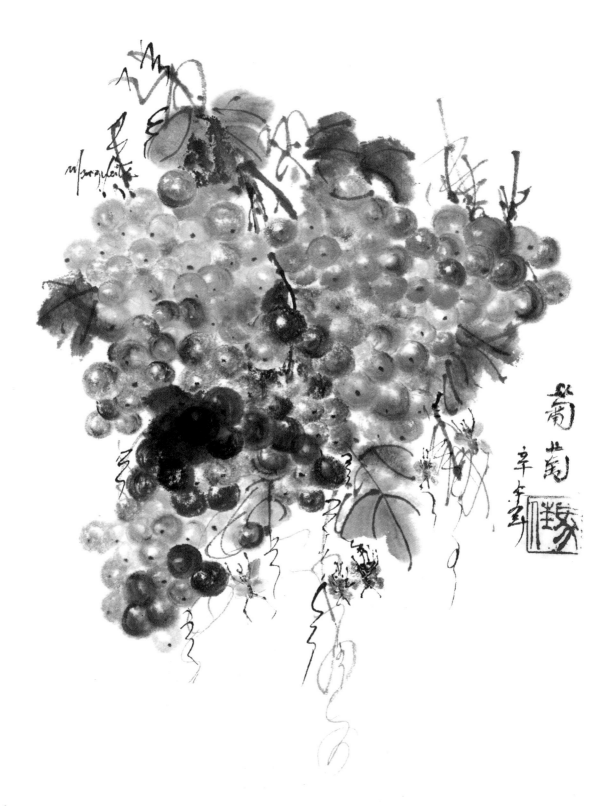

Bees cluster round a bunch of ripening grapes

People

人 物

Unlike other living creatures, in Chinese painting the human figure is almost always depicted in the outlining method. People are painted with a clean, fine outline, and the colour is carefully blended in afterwards.

Traditional paintings of people seldom show any shading on the face, though there is usually some on the clothing. You can blend shadows into robes and even on to faces and hands, but if you want to achieve texture and liveliness remember to vary the pressure of your brush.

There is no reason why you should not break with tradition and depict people in the impressionistic or freestyle way. Here too there will be no shadows, but a sense of life can be conveyed with expressive brush strokes; colour is added as a very light wash.

Many of the examples of paintings of the human figure on the following pages are really landscapes with people, to give a sense of scale. Pure landscape painting is dealt with in more detail on page 107.

OPPOSITE PAGE Figures in a landscape. Normally people are depicted only as tiny elements in a dominating landscape, but here the idea is to show the figures and so they are drawn larger than usual

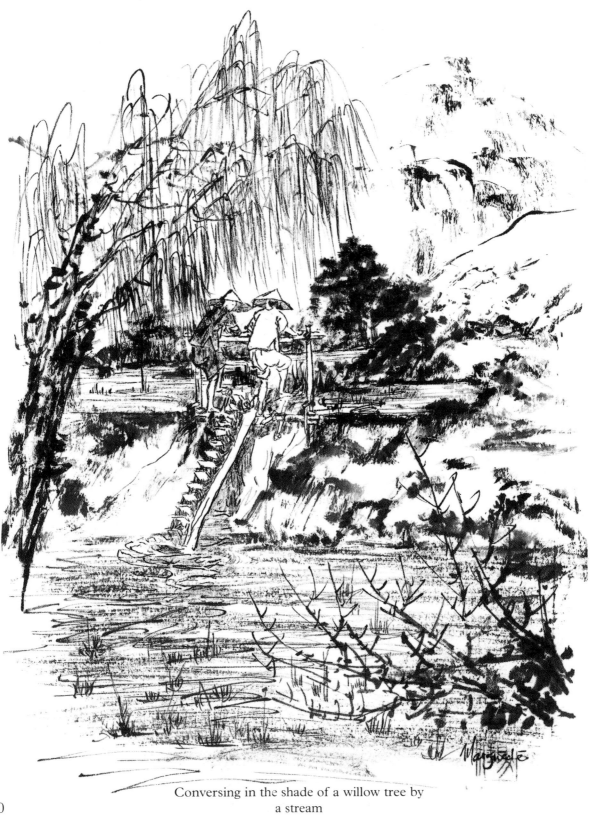

Conversing in the shade of a willow tree by
a stream

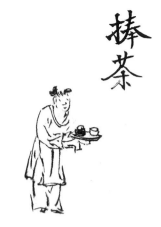

Carrier

Serving woman

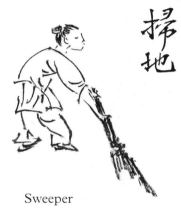

Sweeper

Man with umbrella

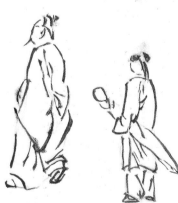

Librarian

Musician and assistant

Traditional Chinese figures

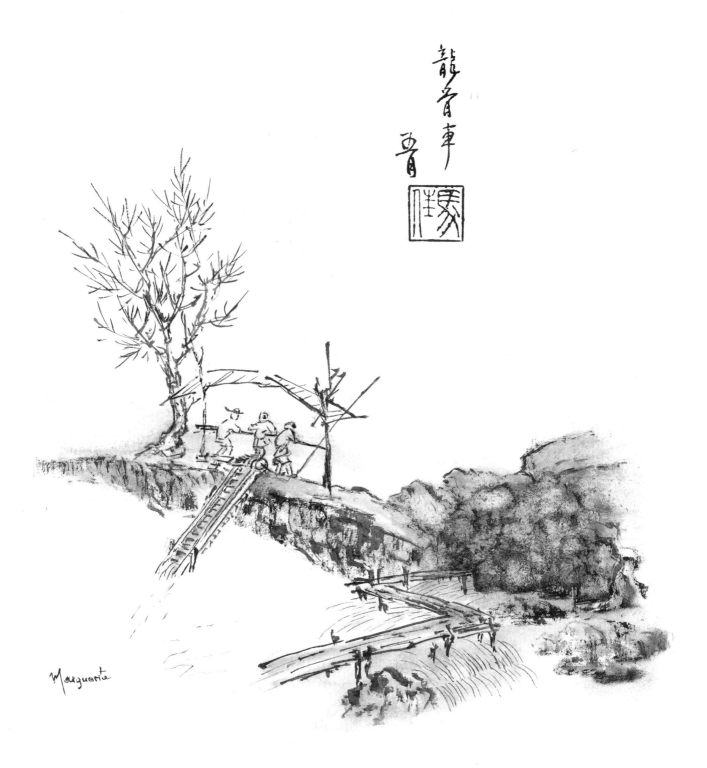

Small figures, large rocks and a tall tree by a river

OPPOSITE PAGE Autumn brings cold winds

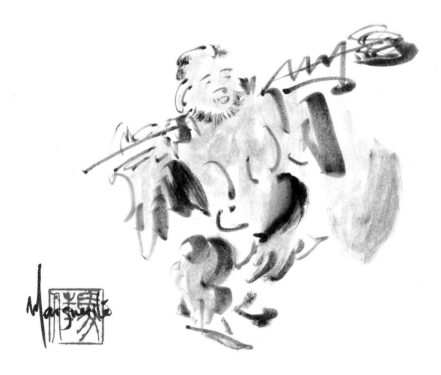

A Chinese peasant painted in the impressionistic
style

OPPOSITE PAGE Musicians dwarfed by the majesty
of mountain peaks

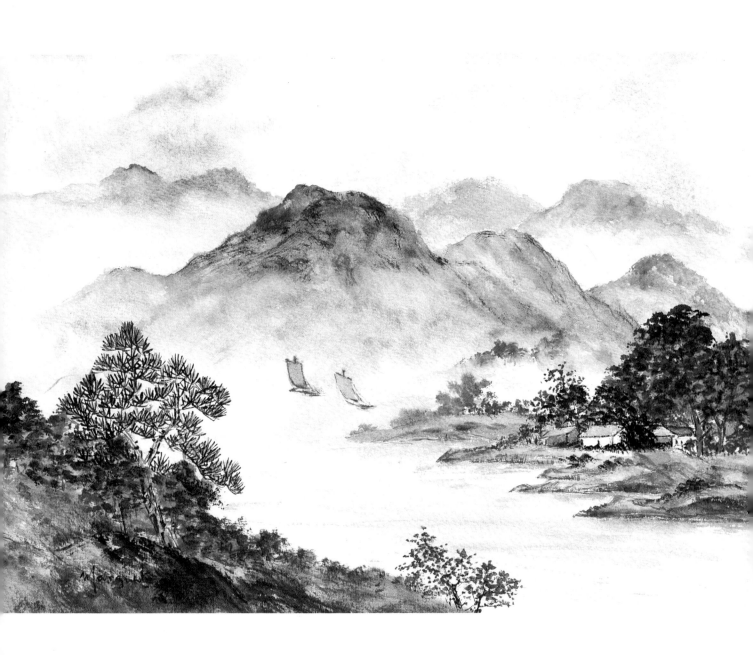

Pine trees, prunus blossom, water and mountains:
classic elements in a traditional Chinese painting

Landscape

山　水　風　景

The Chinese expression for 'landscape painting' means literally 'mountains and water', because the convention was to show generalized views of mountain and river scenery, rather than particular places. The steepness of mountains is particularly emphasized and idealized in such paintings.

Also included in a typical Chinese landscape are water of various kinds, boats, cottages, temples and trees. Human beings are, as shown in some of the paintings on the preceding pages, generally small.

There is a moving perspective in the Chinese landscape. It is a form of enjoyment, like strolling around a lake or walking through a woodland.

Traditional shadows are hardly ever found. Painters did not limit their representation to a particular time of day, any more than to a simple viewpoint.

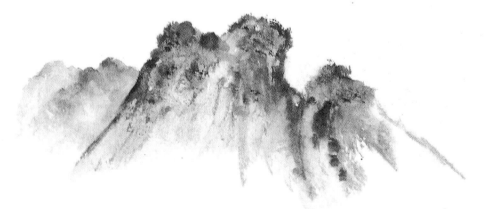

Rugged mountain top with scrub and rough vegetation

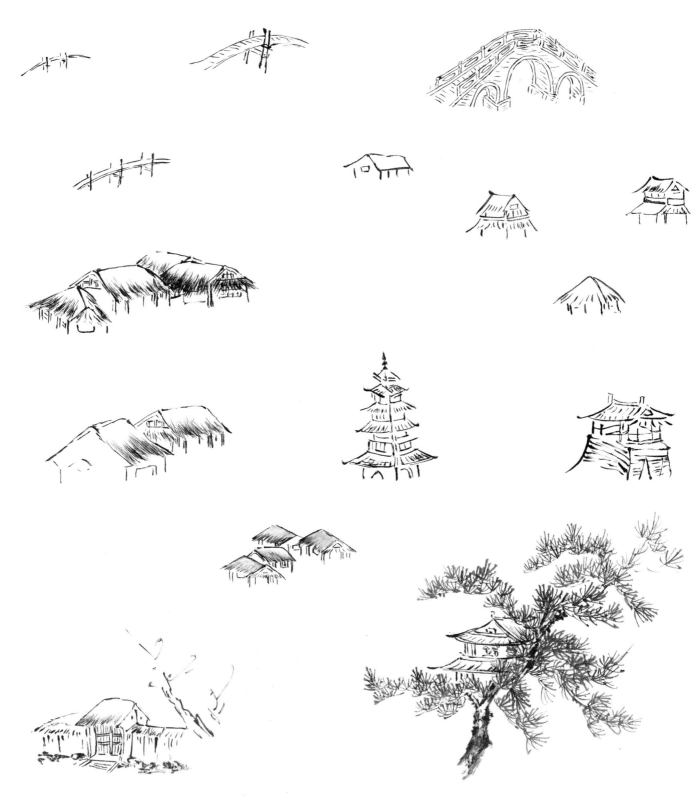

Buildings and bridges for landscape paintings

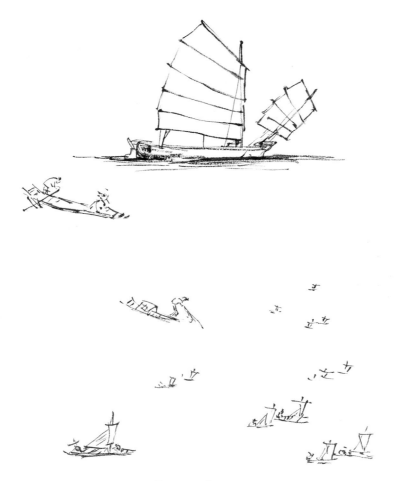

Boats and oarsmen

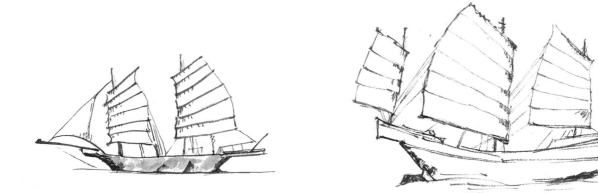

Trading vessels suitable for inclusion in a Chinese
landscape painting: LEFT Malay East Coaster and
RIGHT North China junk

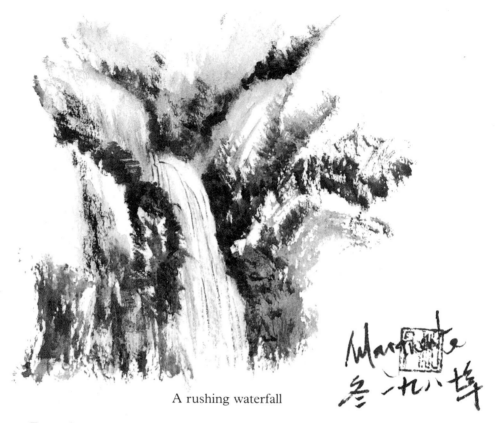

A rushing waterfall

Depicting Mountains
There are three methods of portraying mountains, using different kinds of brush strokes for what are called high distance, deep distance and level distance.

HIGH DISTANCE
This is the view of a mountain top from below. It has a clear, bright tone, and the effect of height is achieved by expressing an upward force in the brush strokes.

DEEP DISTANCE
Here, a feeling of depth is obtained by piling on layer upon layer, achieved by the accentuation of the mountainsides one behind the other, or by a river slowly making its way to the horizon.

A river snakes towards the horizon: an example of
the deep distance technique

LEVEL DISTANCE
The viewpoint here is from another mountain of the same
height. The effect is obtained by the use of misty lines which
gradually disappear. The mistiness separates the area
immediately opposite from the upper two-thirds of the
painting, which are occupied by a massive, centrally placed
mountain.

111

See pages 22–5 for more examples of mountains and rocks in Chinese painting.

General Points for Painting a Landscape

Here are some general guidelines for painting typical elements in a landscape painting. For a waterfall, use a single line. Use short strokes of broken texture to depict the rocky, scrub-covered surface of the mountain top. Include some trees to indicate massed vegetation. A stream falling from one level to the next would connect different areas of the picture.

The foreground of scrubby vegetation is depicted with well-chosen brush strokes

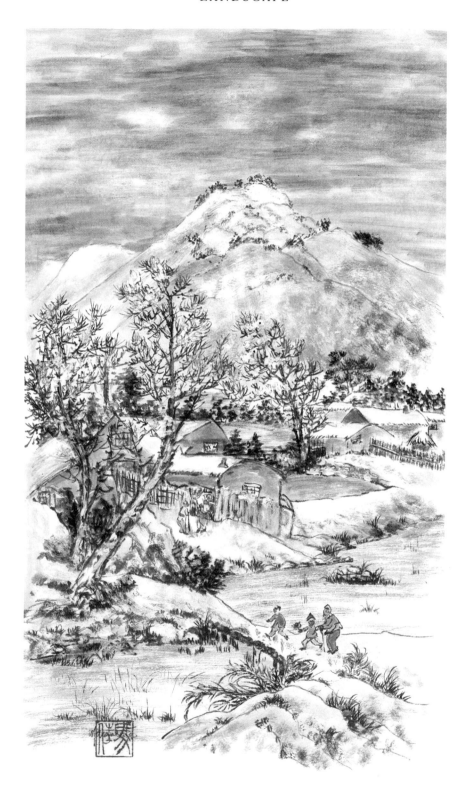

Winter scene with typically small human figures

Calligraphy

書　法　筆　跡

Chinese brush calligraphy became popular in China with the invention of paper in about the second century AD, and has long been regarded as an art. The work, done in ink or watercolour, must be executed in a single flow, without interruption, hesitation or revision.

Four Essential Qualities
Faultless writing should exhibit four qualities. First is a feeling of strength in the strokes, like the bones in a body. Second is a sense of being well-nourished, like the flesh that covers the bones. Third, one stroke should appear to be joined to the next, and likewise one character to the next, by invisible ligaments, just like the muscles in the body. Finally, the ink should have a full texture like blood.

Calligraphic Styles
In the last three thousand or so years there have been a number of broadly defined styles of writing.

SEAL SCRIPTS
These range from oracle bone writing to the small seal style, for example:

　　　　　　　　Seal script

REGULAR BRUSH SCRIPT
This is official script, for example:

鬱　　請　　老　　福　　祿

Regular brush script

GRASS SCRIPT
A shorthand scrawl with highly abbreviated characters which are difficult to read, grass script nevertheless has a loose, swiftly flowing elegance of its own. For example:

馬 马　興 白　樂 楽　讀 渎

Grass script

RUNNING SCRIPT
This is a looser, cursive version of grass script, in which the strokes flow into each other. For example:

Blessing

Prosperity

Longevity

Running script

ARCHAIC SCRIPT

There are some archaic characters found on tortoiseshell and ancient bones that were presumably originally derived from pictographs (pictorial symbols). For example:

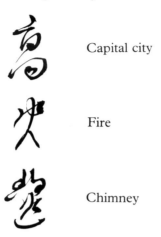

Capital city

Fire

Chimney

Archaic script

A more refined classification specifies at least thirty to forty strokes. For example:

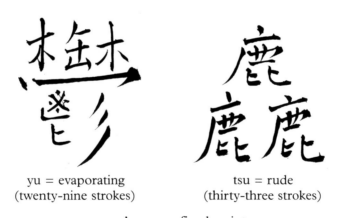

yu = evaporating
(twenty-nine strokes)

tsu = rude
(thirty-three strokes)

A more refined script

The signs of the characters come from drawings (pictographs, as mentioned above), not from letters. Some examples are given at the top of the opposite pages.

Wood

Small forest

Large forest

Characters formed from drawings

Calligraphic Strokes

It is important to know what constitutes a 'stroke', and the order in which the strokes are written. A stroke is the line or mark made between putting the pen or brush to the paper and lifting it off.

Sometimes you need to know the number of strokes in a character in order to look it up in a dictionary. In addition, if you don't follow the right order of strokes when practising calligraphy it is very difficult to achieve the proper harmony and balance.

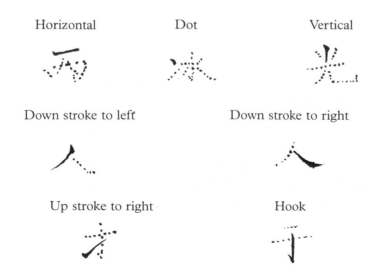

Horizontal	Dot	Vertical
Down stroke to left		Down stroke to right
Up stroke to right		Hook

The basic strokes

Supplementary strokes

THE SEVEN BASIC STROKES

The character 'young', meaning 'eternity', combines the seven basic strokes used in Chinese calligraphy. Although there are many more strokes, this character is an excellent example and is largely determined by the individual brush strokes.

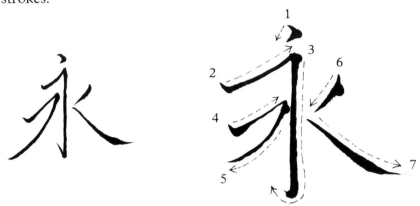

The character 'young'

The character 'ai', meaning 'love', uses thirteen strokes.

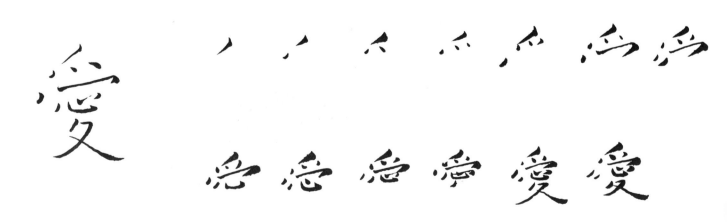

The character 'ai'

Calligraphic Symbols and Poems

書法象徵及韻文

In ancient China painters liked to write inscriptions on their pictures. Certain kinds of inscriptions should go with certain types of picture. Here are a few examples:

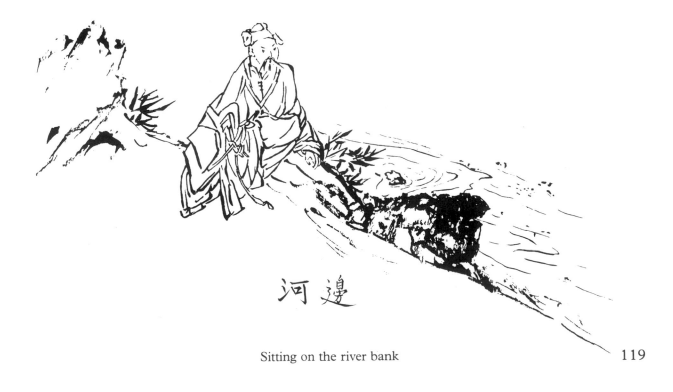

河邊

Sitting on the river bank

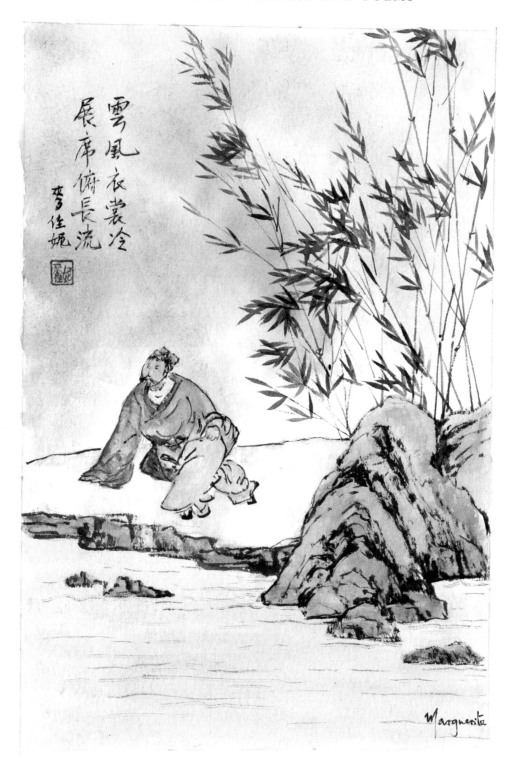

Sitting on a rock flat as a mat, with head bent,
watching the long, flowing stream among the
clouds, his garments became damp and cold

牧童

Shepherd boy

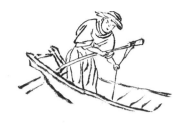

搖槳

Paddling

臥觀山海經

Lying down, reading the *Mountain and Sea Treatise* (an ancient, partly mythological, discourse on geography)

獨立蒼茫自咏詩

Standing alone in the open, reciting a poem

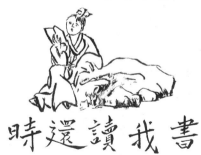

時還讀我書

From time to time I read my book

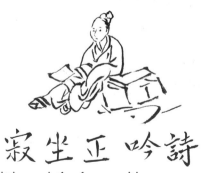

寂坐正吟詩

Sitting quietly alone reciting a poem

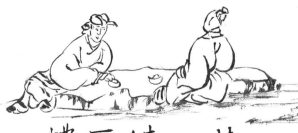

拂石待汲茶

Leaning on a rock, they wait for tea to be poured

高雲共片心

My heart is lifted as the cloud on high

121

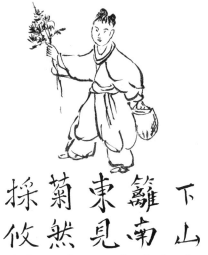

採菊東籬下
攸然見南山

Having gathered chrysanthemums by the bamboo to the east, joyfully contemplating the southern mountain

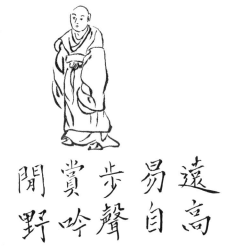

閒賞步易遠
野吟聲自高

Wandering in a leisurely way, one easily strays

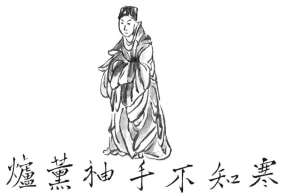

爐薰袖手不知寒

Hands slipped in sleeves are warm. There is no feeling of cold

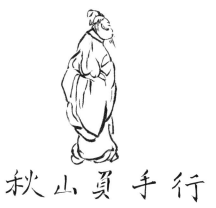

秋山貝手行

With hands clasped behind, walking on a mountain in autumn

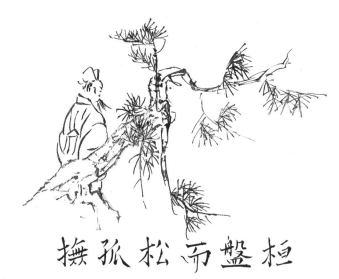

撫孤松而盤桓

Lingering by a solitary pine, reluctant to leave

明月荷鋤歸

Returning home by moonlight, hoe on shoulder

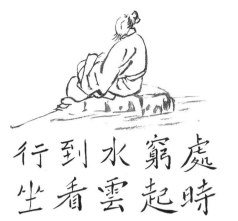

行到水窮處
坐看雲起時

Having walked to where the waters flow no more,
he sits and watches the clouds rise

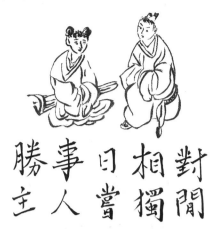

勝事日相對
主人嘗獨閒

Master and servant sitting together; the master
alone has leisure

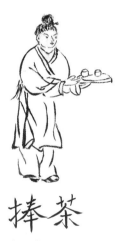

捧茶

Serving tea

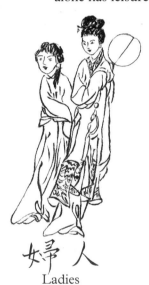

婦人

Ladies

Figures in landscapes have already been looked at on pages 98–105, but here are a few further guidelines. If the depiction of landscape rather than figures is the main purpose of your painting, choose your figures carefully. They should be drawn well and with style, but not in too great detail, and they should be appropriate for the particular scene and bear a relationship to each other. For instance, if you have a

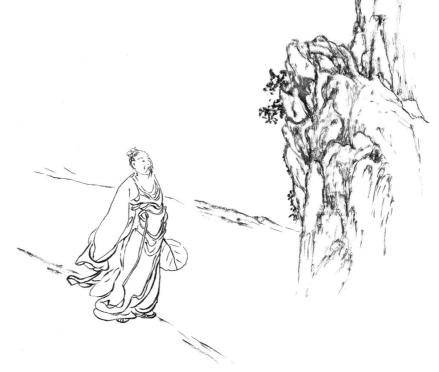

Mountain and human in mutual contemplation

mountain in your painting, a figure should seem to be contemplating it. The mountain, in turn, should seem to be bending over and watching the figure.

A flute player should likewise appear to be listening to the moon, while the moon, calm and still, appears to be listening to the notes of the flute.

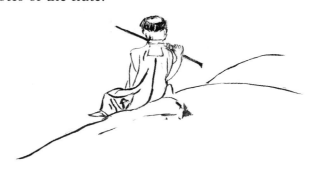

Flute player on a mountainside beneath the moon

124

Bibliography

BUSSAGLI, Mario, *Cassell's Styles in Art: Chinese Painting*, Cassell, 1989

CLAYRE, Alasdair, *The Heart of the Dragon*, Collins, 1984

EVANS, Jane, *Chinese Brush Painting: A Complete Course in Traditional and Modern Techniques*, Collins, London, 1987 and Watson-Guptill, New York, 1987

EVANS, Jane, *Landscape Painting with a Chinese Brush*, HarperCollins, London, 1992

FU SHEN, C.Y., *Studies in Chinese Calligraphy*, Yale University Press, 1980

HEJZLAR, Josef, *Chinese Watercolour*, Cathay Books, 1978

KAI SHAN YUE, *Collection of Art by Kai Shan Yue*, Quan Dong, China, 1988

Selected Chinese Paintings from the Collection of the People's Fine Art Publishing House, Tian Jin, China, 1983

SILCOCK, A., *Introduction to Chinese Art*, Oxford University Press, 1935

WU YANG MU, *The Techniques of Chinese Painting*, Herbert Press, 1990

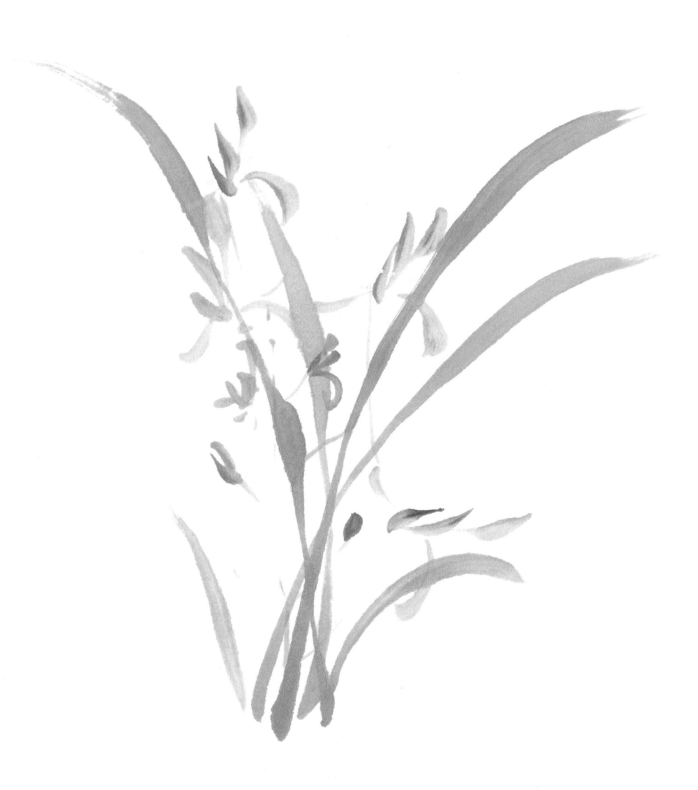

126 Orchids symbolize serenity in obscurity

Index

Numbers in *italic* refer to illustrations

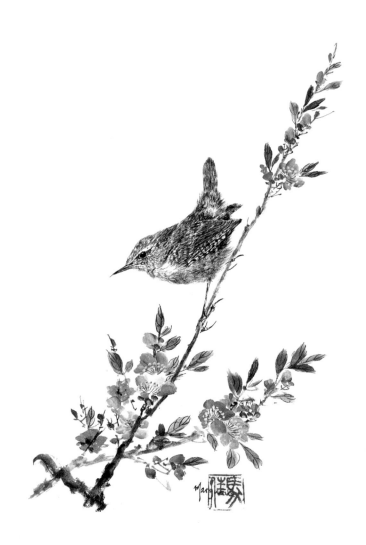

A wren alights on a prunus twig

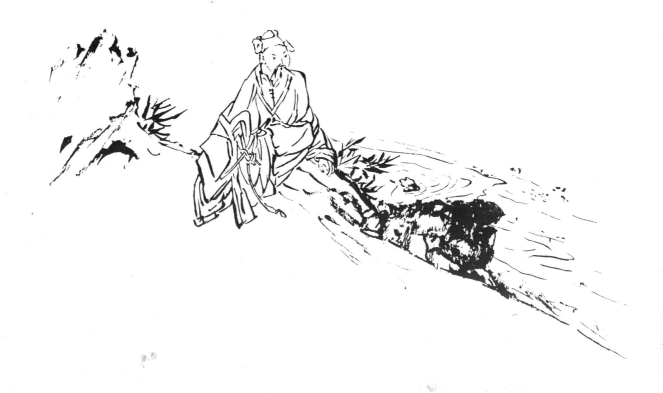